100 things every artist should know

Walter Foster

THE ARTISTS OF WALTER FOSTER

Photograph on page 10, Artwork on pages 22, 25 © Carol Rosinski. Artwork on pages 12, 54-55, 98 ("Lighting the Subject"), 106-107, 109, 122 © Brenda Swenson. Artwork on pages 13,17, 70-71 © Patti Mollica. Artwork on pages 18, 111, 120, 123-125 © William F. Powell. Photographs on page 24, Artwork on page 26 © Diane Cardaci. Artwork on pages 27, 29 © Jacob Glaser. Artwork on page 28 © Christopher Speakman. Artwork on page 30 © Nolon Stacey. Artwork on page 32 © Eileen Sorg. Artwork on pages 34, 38-39, 40 ("Applying Unblended Strokes," "Blending with Fingers," "Blending with a Tortillon,"), 42 © Marla Baggetta. Artwork on page 37 ("Black Construction Paper"), 41 © Lesley Harrison. Artwork on page 40 ("Using a Cloth"), 118 © William Schneider. Artwork on pages 43, 64-65, 112-115, 119 ("Painting Negative Space") © Nathan Rohlander. Artwork on pages 44, 46, 50-51, 92-97, 102-104 © Joseph Stoddard. Photographs on page 48 © Janet Griffin-Scott. Artwork on page 49 © Meredith Dillman. Artwork on pages 52-53 © Pat Averill. Artwork on page 56 © Elin Pendleton. Artwork on page 66 © Lori Lohstoeter. Artwork on pages 67-69, 90, 101 ("Engaging the Viewer), 108 ("Coastal Painting"), 116, 121 © Tom Swimm. Artwork on pages 72, 87-89 © Lucy Wang. Photographs and Artwork on pages 74-77 © David Morton. Artwork and Photographs on pages 78-85 © Cari Ferraro. Artwork on page 99 ("Complementary Color Scheme," "Triadic Color Scheme," "Tetradic Color Scheme") © Joan Hansen. Artwork on page 98 ("Making Elements 'POP'"), 99 ("Analogous Color Scheme") © Geri Medway. Artwork on page 99 ("Split-Complementary Color Scheme") © Rose Edin. Artwork on page 101 ("Catching the Eye"), 108 ("Using Atmospheric Perspective", "Using Muted Colors") © Barbara Fudurich. Artwork on page 108 ("Recognizing Atmospheric Perspective") © Scott Burdick.

Associate Publisher: Rebecca J. Razo
Art Director: Shelley Baugh
Project Editor: Elizabeth Gilbert
Associate Editor: Stephanie Meissner
Production Design: Debbie Aiken, Amanda Tannen
Production Manager: Nicole Szawlowski
Production Coordinator: Lawrence Marquez
Administrative Assistant: Kate Davidson

www.walterfoster.com
Walter Foster Publishing, Inc.
3 Wrigley, Suite A
Irvine, CA 92618

Printed in China.
3 5 7 9 10 8 6 4
18283

100 things every artist should know

Table of Contents

Introduction

Whether you're a seasoned artist or just beginning to explore your artistic side, this book features an educational and inspirational journey in drawing, painting, and other artistic mediums. We've distilled these art forms into 100 of the most important topics, including definitions, demonstrations, tips, shortcuts, and much more. Packed full of expertise from dozens of Walter Foster's notable artists, you'll discover everything from basic pastel techniques to color theory and perspective, organized into several chapters noted below.

General Tools and Materials:
Learn about the most basic art materials, and discover how to set up your workspace.

Pencil Drawing:
Dive into the details of drawing with graphite and colored pencil as you learn techniques for creating a variety of strokes and textures.

Pastel:
Get your hands dirty and discover the unique characteristics of hard, soft, and oil pastel.

Watercolor:
Practice your hand at this fluid and vibrant medium, and find out the best ways to create special effects and more.

Oil and Acrylic:
Master the basics of these similar paints, including brushwork and color mixing.

Additional Mediums:
Touch on less common mediums such as charcoal, airbrush, calligraphy, and even Chinese brush painting.

Color and Light:
Create a sense of mood, time, and place through your treatment of color, light, and shadow.

Perspective and Proportion:
Discover the more technical side of creating realistic artwork, from suggesting depth and distance to representing accurate proportions.

Composition:
Focus on the placement of objects in your artwork and learn how to create dynamic designs.

Read this book from start to finish, or flip through to find a topic that interests you! Regardless of your approach, we're sure you'll discover—or rediscover—valuable information and exciting tips that will enrich your artistic knowledge.

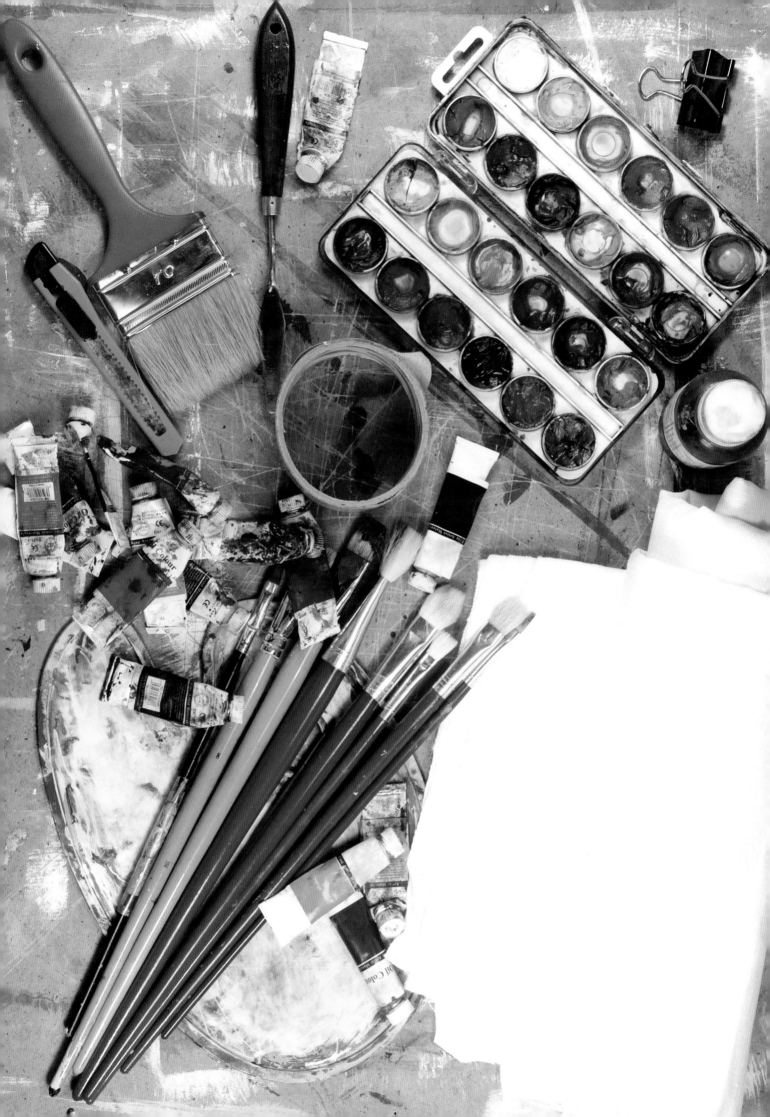

100 things every artist should know

CHAPTER 1

general tools and materials

Setting Up a Studio

Choose your workspace to match your style. Some people like to stand to allow free arm movement; others sit at a table for more precise work; and some prefer to sit in an oversized chair. Select an easel, table, or lap desk to hold your paper while you work. And wherever you do work, you will need good lighting, such as a floor lamp, desk light, or clamp-on light. As an artist, you may prefer to use a "natural" or "daylight" bulb, which mimics sunlight and is easy on your eyes. To avoid blocking the light with your body or hand—if you are right-handed—place the light to your left and above your work; left-handed artists, position your lamp to the right and above.

Drafting or Drawing Table You can angle these tabletops for comfort. If space is short, get a folding table.

Lap Desk A laptop board with an attached pillow allows you to put your feet up, lean back, and draw.

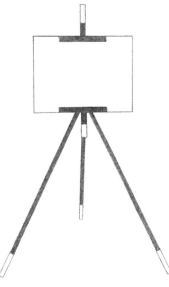

Easel An easel will hold your work upright, so you can work standing or sitting.

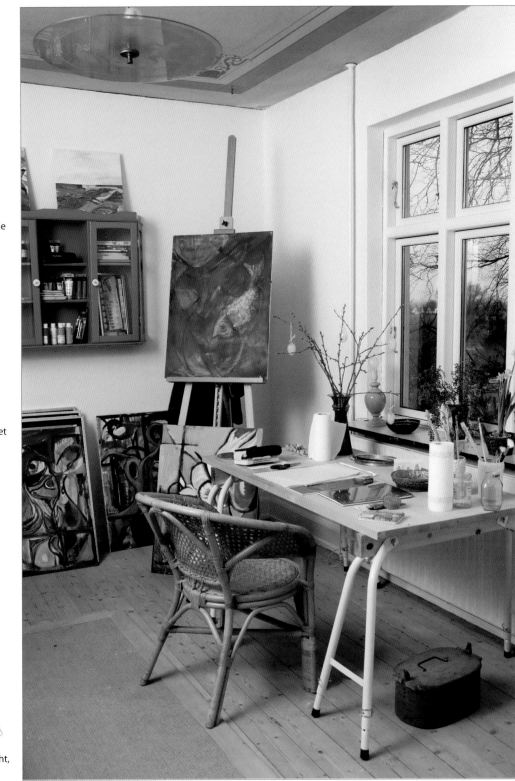

Sketchbooks and Tracing Paper

Sketchbooks

There are all kinds of sketchbooks available, but spiral-bound varieties are great because they lie flat when opened. Sketchbooks come in a variety of sizes, from 6" x 9" to 11" x 14". Stay clear of books with thin paper; denser papers are better able to handle washes of color without bleeding through or warping the paper.

Spiral-bound sketchbooks allow you to remove and replace pages— an advantage if you like to share or frame your sketches.

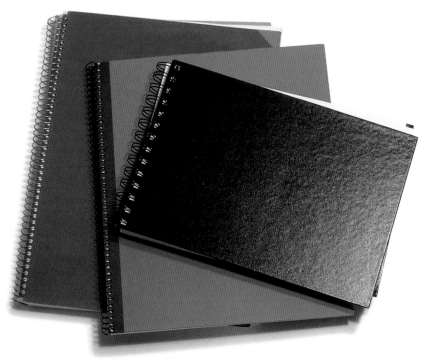

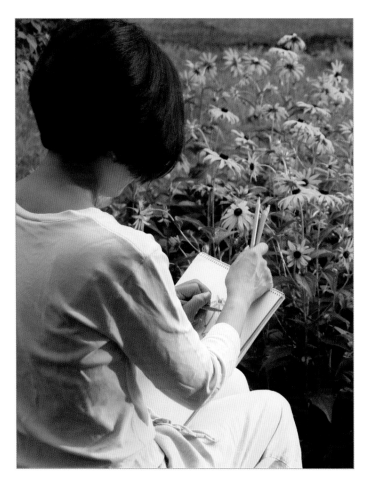

Sketching on Location

One of the great advantages of keeping a sketchbook is that it's small enough to go with you anywhere—from outdoor flower markets to historical buildings! No matter where you are or what you're surrounded by, you have before you a wonderful opportunity to sketch—and don't feel as if you have to wait for the perfect image to begin sketching.

Outdoor sketching requires a different kind of preparation than indoor sketching does. For example, you need to pay attention to the time of day and the weather to be sure you'll have plenty of natural light; between 8:30 and 11:30 in the morning are ideal times to sketch outdoors.

When you arrive, on location, walk around for at least 10 minutes to get a sense of the area. When something captures your interest, take notice of how the sun's position will change the scene during the day. If the focal point of the subject will likely be shrouded in shadow, it won't make a good subject.

Take written notes or make pencil marks on your sketch to record the placement of shadows before they change. If you're planning to turn the sketch into a full painting later, it's a good idea to record information about the time of day, weather conditions, people you meet, and so on—anything that will help you remember!

Drawing and Painting Surfaces

The surface on which you draw or paint (also called the "support") will always influence the quality of your final artwork. Subtleties in texture, the vibrance of the paint, and the length of your art's life are just a few things tied up in the support. Before you make a trip to the art store for supplies, check out this overview of paper and canvas.

Drawing Paper

Paper can vary in weight (thickness), tone (surface color), and texture. It's a good idea to start out with smooth, plain white paper so you can easily see and control your strokes. Then check out other options. Paper with a rough texture (also called "tooth") is ideal for charcoal and pastel—and it may even appeal to graphite artists drawn to bold, broken strokes. Note that using acid-free, archival paper will increase the lifespan of your art by preventing it from yellowing and becoming brittle.

Watercolor Paper

This paper is coated with a layer of sizing, which helps the surface absorb the paint slowly. A variety of textures exist on the market, notably *hot-press* (smooth), *cold-press* (textured), and *rough* (just what it sounds like). Watercolor paper is also labeled by weight. A common beginner paper is 140-lb paper, which is thick enough not to buckle or warp excessively under the moisture of paint.

Canvas

Pre-primed and stretched canvas, which is available at arts and crafts stores, is the best way to go for acrylic and oil painting. This canvas is stretched taut over a wood frame and coated with acrylic *gesso*—a white primer that provides an ideal surface for holding paint. Without it, the canvas may awkwardly absorb the paint or become damaged when exposed to the harsh solvents (as used in oil painting). Also, gesso's bright white color helps the layers of paint above it glow.

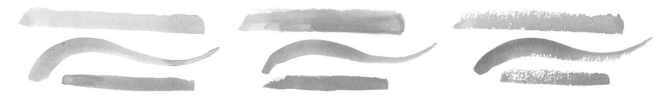

Smooth paper Medium paper Rough paper

More Painting Surfaces

Painting surfaces, also called "substrates," have different textures and lend a special effect to your work.

Canvas Paper

This is commercially prepared paper that simulates canvas texture and weave but is available in pad form. It does not require priming and is less expensive than actual canvas—perfect for practicing new techniques.

Cardboard and Mat Boards

These are wonderful surfaces for painting because they are economical, lightweight, and readily available. Many framers will freely give their leftover mat boards scraps if you ask. These surfaces require two coats of gesso before using.

Papers and Boards

Many artists paint on watercolor paper, print-making papers (used with inks and printing presses), and Bristol board (available in pads). You can use these surfaces either primed or unprimed. To minimize the buckling and warping of papers, you can tape the sides down to a stable surface, wet the entire paper, and let it dry completely. This "pre-stretches" the paper so that it will retain its flat quality when you paint on it. Another way to minimize buckling is to prime both the front and back of the paper with one or two coats of gesso; then let it dry before beginning your painting.

Traditional Painting Surfaces:
A. Canvas paper
B. Masonite or hardboard
C. Pre-primed canvas panels
D. Canvas
E. Watercolor paper
F. Primed mat board

Hardboard and Panels

Many artists paint on smooth, hard, inflexible surfaces, such as hardwood (oak, cedar, birch, walnut, etc.); medium density fiberboard (MDF) such as Masonite; and plywood. These must be primed with two or three coats of an acrylic polymer medium because they contain resins and impurities that can leech up into your painting and cause noticeable discolorations—called Support Induced Discoloration (SID)—especially if you are using transparent gels and mediums.

Fabrics

Rather than painting on a white canvas or paper, use any fabric as a starting point for creating a painting. Add paint, gels, and pastes just the way you would if working on canvas. Use several coats of an acrylic polymer medium to prime, if desired.

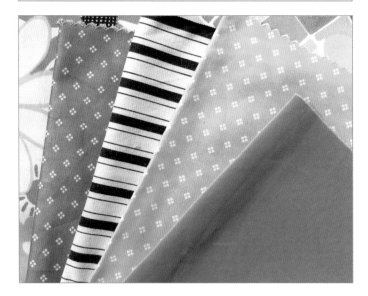

Feel free to experiment with a variety of different surface textures to see which works best for your art.

Easels

Life-sized paintings require large canvases, which in turn require a solid, secure, upright easel. The easel can be wall-mounted or freestanding. For painting on site, such as outdoors or in a client's home or office, use a portable easel.

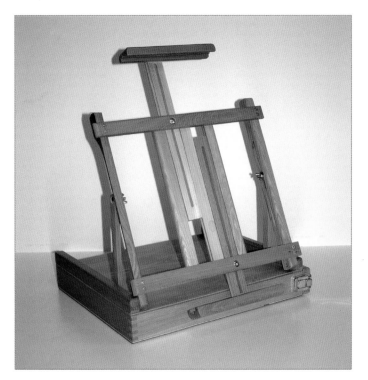

An easel is a structure made to hold your support in place while you paint. Most easels hold your support upright vertically, but some, such as French easels or box easels, are adjustable so that you can tilt the surface to different angles when necessary. Portable easels are lightweight and collapsible, making them ideal for painting on location or taking into the studio; tabletop easels are often a more comfortable choice, as you can sit while you paint. When painting in watercolor, it's usually best to paint on a flat surface so the paint doesn't run or drip quite so much. In this case, you may want to consider a painting board, which is any flat, stiff surface used to support your painting. Popular choices for painting boards include hardboard, wood, and Plexiglas®. Many boards have carrying handles, and some come with clips that will hold your paper in place.

Tilting the paper Some artists prefer a tabletop easel so they can tilt their paper up, causing the paint to run down the page instead of collecting into puddles on flat paper. If you don't have an easel, try propping up your painting surface with a few books.

French Easel This all-in-one easel has three adjustable-length legs that fold up into a box. This box, which carries like a vertical briefcase, also holds painting materials and canvas.

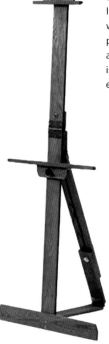

Light Studio Easel Lighter easels like this one are best for smaller works and for viewing reference photographs while painting. If you are handy or know of someone who is, you can easily make this type of easel at home.

Brushes

Rounds

The round brush is a good choice for delicate work because the tip gradually tapers to a fine point that becomes even finer when wet. Capable of producing a variety of strokes, the round can be manipulated by changing both the pressure on the brush and the consistency of the paint. Use firm pressure for wide lines and light pressure for thin lines. Or paint fine details by pressing lightly and using the very tip of the brush. It's a good idea to start out with three round brushes—one large, one medium, and one small. Rounds are available in sizes ranging from 1/6" to 3/8".

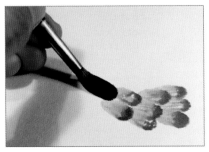

Flat Stamping To create textured patterns, like that of feathers, hold a round brush flat against the painting surface and press the tip of the brush down in a stamping motion.

Filberts

The uniquely shaped *filbert* brush has a curved tip that comes to a fine point capable of producing very thin lines. The stiffness of the brush, coupled with its unique curve, allows you to create a number of interesting textures. The bristles are highly absorbent and can hold large amounts of paint. Filberts are similar to flat brushes, but they have distinctly rounded tips that are ideal for creating texture.

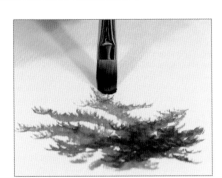

Creating Texture Use the curve of the filbert, changing angles often, to produce a number of textures, such as the foliage here.

Flats

A flat brush will help you apply flat and graded washes and backgrounds. The length of hair in a flat brush is usually one-and-a-half times the width of the ferrule, creating a flexible brush that bends easily. The flat brush is capable of creating both soft blends and delicate glazes. Use this brush to gently layer one color over another or to create long pulls of color. A flat brush's long bristles hold a lot of paint, so you don't have to make multiple trips back to your palette.

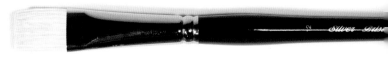

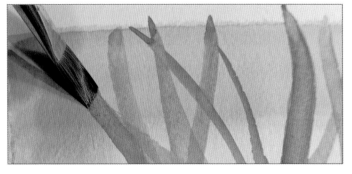

Pulling Color The flexible flat brush, which provides good control, is capable of making long pulls of color such as these blades of grass.

Specialty Brushes

In addition to rounds and flats, there are other brushes available for just about every purpose imaginable, including creating textured patterns, such as feathers and fur, or painting extremely fine details, such as eyelashes or animal whiskers.

Liner Brushes Liner brushes are thin brushes with bristles that taper to an extremely fine point.

Fan Brushes Designed in the shape of a fan, these brushes can be used to create the appearance of trees, animal fur, and feathers.

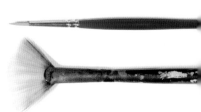

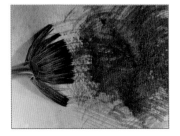

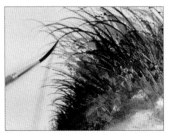

Sweeping Strokes Load a fan brush with heavily diluted paint and pull it over a dry area using short, sweeping strokes to create wispy, hairlike patterns.

Controlled Lines You can use a liner brush to paint long, thin blades of grass or to sign your painting.

Brush Bristles and Care

Synthetic-Hair Brushes

Synthetic brushes are made of nylon or other non-animal products that mimic the qualities of natural hair; they are preferred for use with acrylic paint. The slick bristles of synthetic brushes help the paint slide off easily onto the painting surface. And because paint is easily removed from the bristles, cleanup is more convenient than it is when working with natural-hair brushes. Synthetic brushes come in all shapes and sizes—from thin, delicate bristles that resemble the natural-hair sable brush to thicker, stiffer brushes that imitate the hog-haired bristle brush.

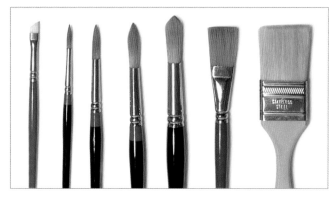

Building a Collection Many artists use solely synthetic brushes (shown here), but some artists prefer a selection of both natural and synthetic brushes. With experience, you will develop your own preferences.

Bristle Brushes

Bristle brushes are a type of natural brush most often used in oil painting. Made with white hog bristles, these stiff, wiry brushes are good for creating patterns and textures or for lifting out color.

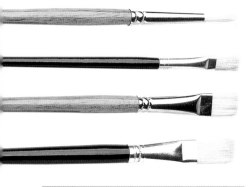

Bristle Brushes Each individual bristle is naturally "flagged" (or split), so that the ends of the bristles hold more paint—every split bristle acts as a miniature paintbrush.

Removing Color Bristle brushes can also be used to remove wet color from the painting surface; scrub the tip of the brush over recently applied paint.

Soft-Hair Brushes

Soft-hair brushes are made from the hair of a variety of different animals, including horses, squirrels, oxen, badgers, monkeys, and even skunks. Pure red sable paintbrushes—cut from the hairs of the tail of the kolinsky (a type of mink native to Siberia)—are considered the best type of brush.

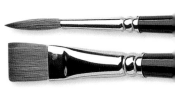

Natural-hair Brushes have resilient bristles and can absorb an ample amount of paint, allowing precision and control.

Loading the Brush This flat natural-hair brush is capable of holding large loads of color for washes or for mixing.

Brush Care

Your brushes will last a long time if you care for them properly. During a painting session, keep the bristles of your unused brushes submerged in clear water—but don't submerge the wooden handle. And never leave the brushes standing in water between sessions. Also, never let a brush sit with paint in its bristles, even during a painting session. And when you finish a painting session, be sure to thoroughly clean your brushes.

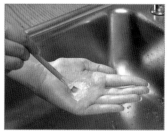

Cleaning Your Brushes To properly clean your brushes without damaging their delicate hairs or bristles, first rinse the brush in cool water; then use paper towels to wipe off as much paint as possible. (Always pull straight away from the bristles—never pull sideways.) Then, using a mild soap or shampoo and cool water, gently rub the bristles in the palm of your hand (as shown) to loosen any remaining paint. Rinse thoroughly and blot with a paper towel. Finally reshape the bristles with your fingers and lay the brush flat on a paper towel to dry.

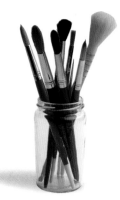

Storing Your Brushes Keep dry brushes standing upright in a jar—you will ruin your brushes if you leave the hairs or bristles standing in water. You also can store brushes in cylindrical containers, which are useful for carrying outdoors. But make sure the container is kept upright, or the bristles might get bent.

Palette Knives and Other Implements

Palette knives, which are used for mixing paint colors, can also be used to apply paint to your surface. Many artists create paintings using only palette knives; they apply the paint as if they are frosting a cake. This will result in a thicker, richer application of paint and produces a very different look than a paintbrush does.

Metal palette knives with a diamond shape and point at the tip allow artists to create fine lines and details, such as branches, sailboat masts, telephone lines, and so on. They are also useful for mixing paint, and you can clean them with one wipe of a towel.

Listed below are additional tools you can use to apply paint.

• Sponges	• Toothbrushes
• Foam brushes	• Feathers
• Putty knives	• Hair-color bottle applicators
• Cardboard strips	• Eye droppers
• Rubber stamps	• Cake decorating materials

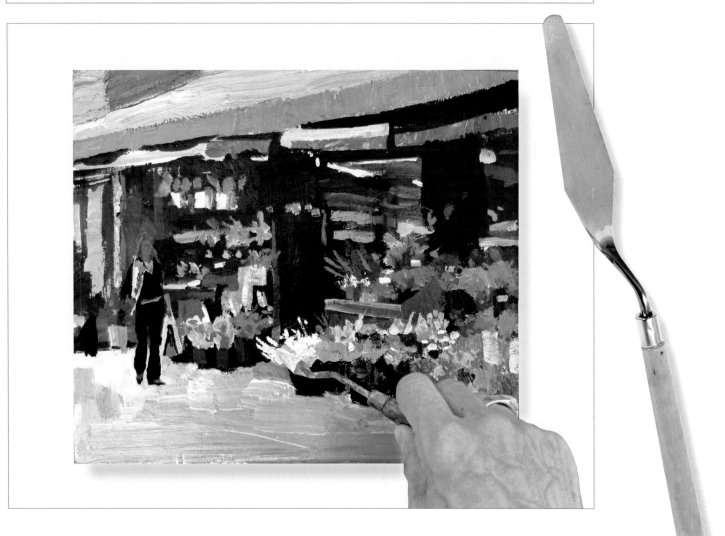

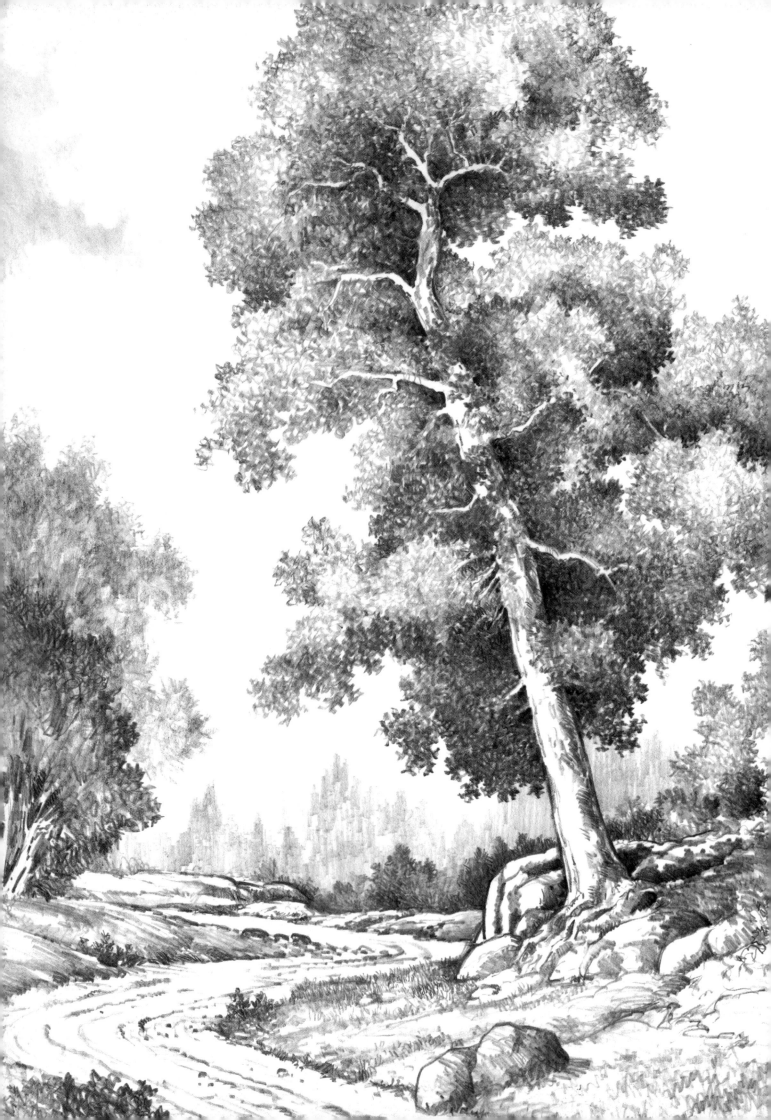

100 things every artist should know

CHAPTER 2
pencil drawing

Introduction to Drawing

From simple doodles and geometric patterns to photorealistic renderings, drawing can result in a vast range of styles and degrees of intricacy. But the importance of drawing isn't about breadth—it's about what the process cultivates within the artist.

You may have heard the saying, "Drawing is the foundation of all art"; this statement hits the nail on the head. Drawing (most simply described as mark-making on a two-dimensional surface) forces us to concentrate on the most basic of the elements and principles of art as we attempt to represent the world around us. Drawing promotes the study of proportion, form, light, shadow—everything you need to thoroughly grasp before moving on to other forms of visual art, such as painting or sculpture. Essentially, drawing teaches you to see the world as an artist and lay the groundwork as a draftsman.

There's a whole host of drawing media available, from graphite pencil to charcoal, which yields intense, velvety black strokes. Other options include colored pencil, pen and ink, and conte crayon. As exciting and exotic as some of the possibilities sound, begin your drawing journey simply with a set of graphite and a set of colored pencils, as well as a pencil sharpener, a kneaded eraser, a rubber eraser, blending stumps, and, of course, drawing paper.

Ready to Start?

Here's what you'll need: graphite and colored pencils, pencil sharpener, erasers (kneaded and rubber), blending stumps (also called tortillons), and drawing paper.

Drawing Pencils

Drawing pencils contain a graphite center. They are sorted by hardness, or grade, from very soft (9B) to very hard (9H). A good starter set includes a 6B, 4B, 2B, HB, B, 2H, 4H, and 6H. Pencil grade is not standardized, so it's best for your first set of pencils to be the same brand for consistency. The chart at right shows a variety of pencils and the kinds of strokes that are achieved with each one. Practice creating different effects with each one by varying the pressure when you draw. Find tools that you like to work with. The more comfortable you are with your tools, the better your drawings will be!

Pencil Key

• Very hard: 5H–9H
• Hard: 3H–4H
• Medium hard: H–2H
• Medium: HB–F
• Medium soft: B–2B
• Soft: 3B–4B
• Very soft: 5B–9B

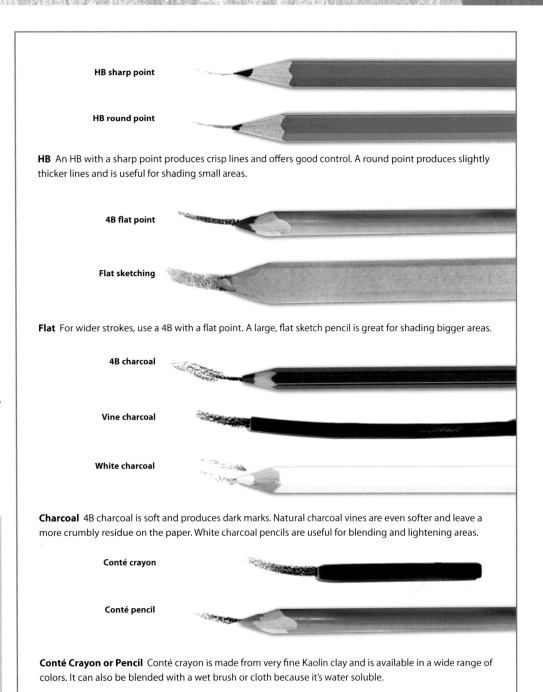

HB sharp point

HB round point

HB An HB with a sharp point produces crisp lines and offers good control. A round point produces slightly thicker lines and is useful for shading small areas.

4B flat point

Flat sketching

Flat For wider strokes, use a 4B with a flat point. A large, flat sketch pencil is great for shading bigger areas.

4B charcoal

Vine charcoal

White charcoal

Charcoal 4B charcoal is soft and produces dark marks. Natural charcoal vines are even softer and leave a more crumbly residue on the paper. White charcoal pencils are useful for blending and lightening areas.

Conté crayon

Conté pencil

Conté Crayon or Pencil Conté crayon is made from very fine Kaolin clay and is available in a wide range of colors. It can also be blended with a wet brush or cloth because it's water soluble.

Sharpening Your Drawing Implements

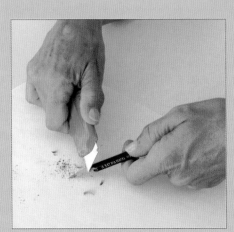

A Utility Knife can be used to form a variety of points (chiseled, blunt, or flat). Hold the knife at a slight angle to the pencil shaft, and always sharpen away from you, taking off a little wood and graphite at a time.

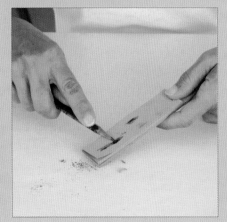

A Sandpaper Block will quickly hone the lead into any shape you wish. The finer the grit of the paper, the more controllable the point. Roll the pencil in your fingers when sharpening to keep its shape even.

Erasers

Graphite is easy to manipulate with erasers. Not only can you correct mistakes, but you also can use them to soften lines, create lighter shading, pull out highlights, and even draw. The process of creating light areas or shapes on a darker graphite background is called "lifting out." The three basic types of erasers are featured below. Let the effect you want to achieve guide your choice of eraser.

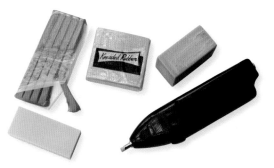

Stick Eraser Hold this eraser as you would a pencil. Trim the tip to a point or a sharp wedge, as shown.

Kneaded Eraser You can mold this puttylike eraser into any shape you need—large or small, pointed or blunt.

Pillow Eraser This cloth-covered tool is made of tiny pieces of eraser that are released through a loose weave, allowing you to lift out large areas of graphite.

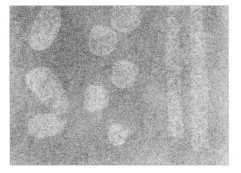

Lifting Out Mold your kneaded eraser into a blunt edge and touch the paper lightly. When you lift up, you'll leave behind subtle variations of light that are appropriate for soft highlights.

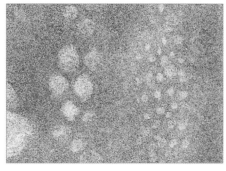

Forming Patterns Roll the kneaded eraser into a sharp tip and dab at the graphite-covered surface in a jabbing motion. This can produce a light, patterned effect.

Pinching Shapes Pinch your kneaded eraser into a wedge shape to create soft, crescentlike areas; this is ideal for lifting out highlights in curly hair or creating subtle folds in fabric.

Drawing Shape a kneaded eraser; then gently press down and lift up and away. Repeat if needed. Then accent your shapes with pencil strokes to make them seem to pop off the paper.

Creating Detail With the sharp point of a stick eraser, stroke or draw into the graphite to reveal the paper underneath for intricate details, such as highlights on water or metal.

Stroking Lines Cut a stick eraser's tip into a wedge. Use the edge lengthwise and pull to erase long, sharp, crisp lines for objects such as leaves, stems, or twigs.

Working with a Battery-Powered Eraser

The spinning point of a battery-powered eraser can create fine details with little effort. "Draw" with this eraser by holding it like a pencil. You quickly can create clear contrasts between light and dark areas, providing sharp edges and areas of focus. Lift out small reflections, produce sparkles on snow, or suggest the shiny texture of metal. Use a metal erasing shield for precise shapes.

Other Tools

There are a number of other supplies you may need before you begin drawing.

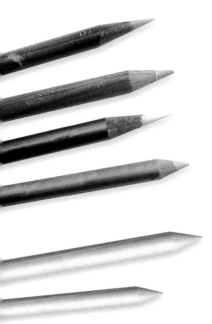

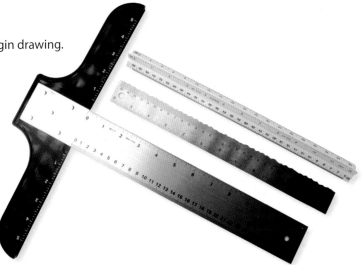

Colorless Blenders These tools are basically colored pencils without any pigment, and they are great for creating smooth, shiny blends. After applying two or more layers of different colors, work these pencils on top to blend the colors together. The surface of the paper will become a little slick after using a blender, so any colors you add over the blended layer will glide easily on the page.

Blending Stumps These paper tools can be used to blend and soften pencil strokes in areas where your finger or a cloth is too large. You also can use the side to quickly blend large areas.

Rulers Use a ruler or T-square to mark the perimeter of your drawing area, ensuring that it is square before taping it to your drawing surface. Never hesitate to use a ruler when drawing to create hard lines that need to be straight, such as the lines of buildings.

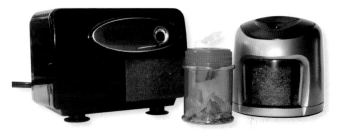

Artist's Tape Use artist's tape to attach your paper to your drawing surface, such as a table or mounting board. This kind of tape is acid-free and can easily be removed without damaging the paper. Even when using this type of tape, take special care when removing the tape. Pull the tape outward, away from your drawing, so that if a tear does start you won't damage your work.

Sharpeners You can achieve various effects depending on how sharp or dull your pencil is, but generally you'll want to keep your pencils sharp at all times. Hand-held sharpeners, electric sharpeners with auto stop, and battery-powered sharpeners are all useful. Experiment with different sharpeners for varied effects. You can also use a sandpaper pad to refine a pencil point.

Workable Fixatif

Net Wt. 11 oz • 311 g

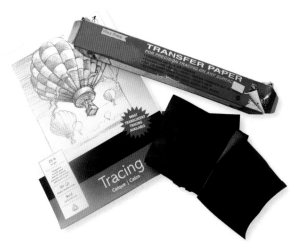

TRANSFER PAPER

Tracing

Extras Use a dust brush to gently remove pencil residue from your paper, as your hand can smear the color and blowing on the paper can leave drops of saliva. You might also want to purchase a can of spray fixative to protect your finished work.

Tracing and Transfer Paper Tracing and transfer paper allows you to transfer a drawing to a clean sheet of paper. For more information on tracing and transferring, see "Tracing and Transferring Images," on page 33.

Handling a Pencil

You can create an incredible variety of effects with a pencil. By using various hand positions, you can produce a world of different lines and strokes. If you vary the way you hold your pencil, the mark the pencil makes changes. It's just as important to notice your pencil point. The point is every bit as essential as the type of lead in the pencil. Experiment with different hand positions and pencil points to see what your pencil can do.

There are two main hand positions for drawing. The writing position is good for very detailed work that requires fine hand control, as well as for texture techniques that require using the point of the pencil. The underhand position allows for a freer stroke with more arm movement—the motion is almost like painting.

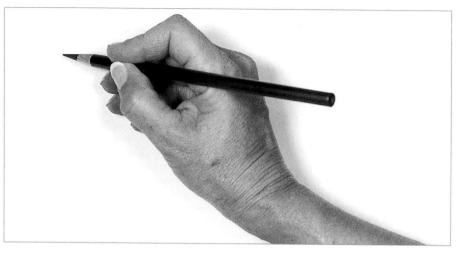

Using the Writing Position The writing position is exactly what it sounds like! Hold the pencil as you normally do while writing. Most of your detail work will be done this way, using the point of the pencil.

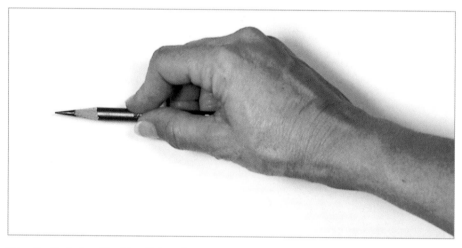

Using the Underhand Position Pick up the pencil with your hand over it, holding the pencil between the thumb and index finger; the remaining fingers can rest alongside the pencil. You can create beautiful shading effects from this position.

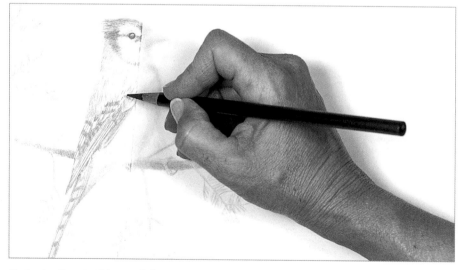

Protecting Your Art It's a good idea to use a piece of tracing paper as a barrier between your hand and your drawing. The tracing paper not only prevents you from smudging your drawing, but it also keep oils from your skin from damaging the art.

Practicing with Your Tools

It's easy to learn how to draw by experimenting. So gather your materials and get ready to have fun! To get you started, try the exercises shown here. Then use these images as inspiration for your own experiments. Remember that your doodles don't have to look like the real subjects—just become familiar with the feel of the pencil against the paper. Be sure to play with different grades to see how soft and hard leads respond to the paper. Try different brushing techniques, and use your eraser too.

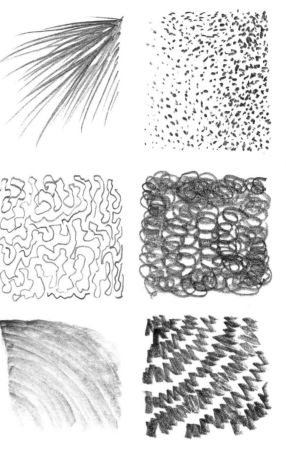

Try Out Different Pencils Make a scribble-art design and fill it in using different grades of pencil. Making these marks side by side will help you become familiar with the different pencil grades, as well as the pressure you need to apply to create a specific value, which is the relative lightness or darkness of the graphite.

Feel the Pencil Against the Paper Make fluid lines, short lines, zigzagged lines, swirls, dots, and continuous circular lines. Use both the point and side of your pencil. Notice how the pencil feels on the paper as you make different kinds of lines and marks. Let your wrist and arm move freely as your pencil meets the paper, and try out a variety of strokes with different grades of pencils. (The doodles above left were made with a 2H pencil; those above right were made with a 2B pencil.)

Pull Out Forms Brush a sheet of white paper with loose graphite to create toned paper. Shape a kneaded eraser and pull out the graphite to create a scene; then use a pencil to add darker outlines.

Create and Define Shapes With a brush and loose graphite, make a line of distant trees. Draw some bushes in front by lifting out the tops with a kneaded eraser. Then use a soft pencil to stroke in some trunks and limbs.

Practicing Lines

When drawing lines, it is not necessary to always use a sharp point. In fact, sometimes a blunt point may create a more desirable effect. When using larger lead diameters, the effect of a blunt point is even more evident. Play around with your pencils to familiarize yourself with the different types of lines they can create. Make every kind of stroke you can think of, using both a sharp point and a blunt point. Practice the strokes below to help you loosen up.

Drawing with a Sharp Point First draw a series of parallel lines. Try them vertically; then angle them. Make some of them curved, trying both short and long strokes. Try some wavy lines at an angle and some with short, vertical strokes. Have fun making a spiral and then try grouping short, curved lines together. Practice varying the weight of the line as you draw. Little Os, Vs, and Us are some great basic shapes.

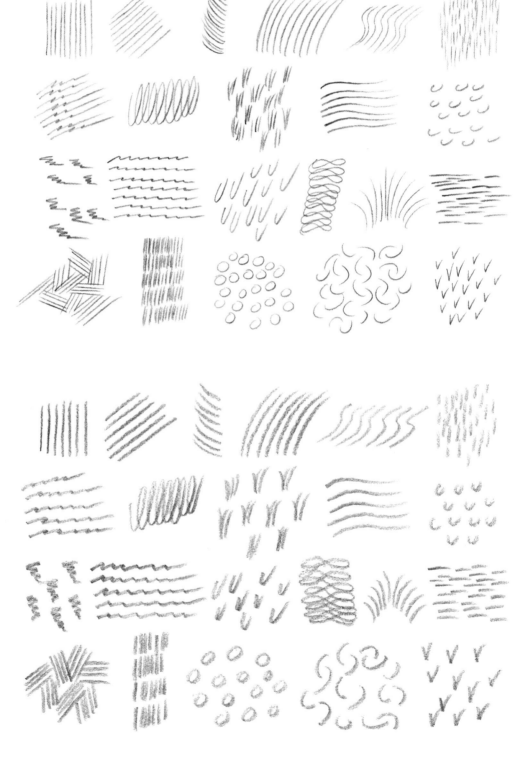

Drawing with a Blunt Point It is good to take the same exercises and try them with a blunt point. Even if you use the same hand positions and strokes, the results will be different when you switch pencils.

Basic Pencil Techniques

You can create an incredible variety of effects with a pencil. By using various hand positions and shading techniques, you can produce a world of different stroke shapes, lengths, widths, and weights. It's also important to notice your pencil point. The shape of the tip is every bit as essential as the type of lead in the pencil.

Practicing Basic Techniques

By studying the basic pencil techniques below, you can learn to render a variety of textures. Whatever techniques you use, remember to shade evenly. Shading in a mechanical, side-to-side direction, with each stroke ending below the last, can create unwanted bands of tone throughout the shaded area. Instead, try shading evenly in a back-and-forth motion over the same area, varying the spot where the pencil point changes direction.

Hatching This basic method of shading involves filling an area with a series of parallel strokes. The closer the strokes, the darker the tone will be.

Crosshatching For darker shading, place layers of parallel strokes on top of one another at varying angles. Again, make darker values by placing the strokes closer together.

Gradating To create gradated values (from dark to light), apply heavy pressure with the side of your pencil, gradually lightening the pressure as you stroke.

Shading Darkly By applying heavy pressure to the pencil, you can create dark, linear areas of shading.

Shading with Texture For a mottled texture, use the side of the pencil tip to apply small, uneven strokes.

Blending To smooth out the transitions between strokes, gently rub the lines with a blending tool or tissue.

Creating Form

The first step when creating an object is to establish a line drawing to delineate the flat area that the object takes up. This is known as the "shape" of the object. The four basic shapes—the rectangle, circle, triangle, and square—can appear to be three-dimensional by adding a few carefully placed lines that suggest additional planes. By adding ellipses to the rectangle, circle, and triangle, you've given the shapes dimension and have begun to produce a form within space. Now the shapes are a cylinder, sphere, and cone. Add a second square above and to the side of the first square, connect them with parallel lines, and you have a cube.

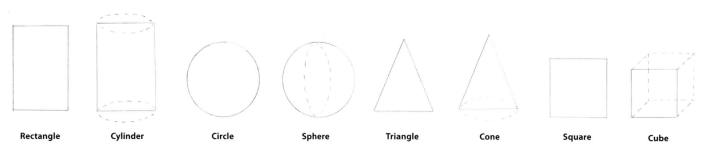

Rectangle Cylinder Circle Sphere Triangle Cone Square Cube

Adding Value to Create Form

A shape can be further defined by showing how light hits the object to create highlights and shadows. First note from which direction the source of light is coming. (In these examples, the light source is beaming from the upper right.) Then add the shadows accordingly, as shown in the examples below. The *core shadow* is the darkest area on the object and is opposite the light source. The *cast shadow* is what is thrown onto a nearby surface by the object. The *highlight* is the lightest area on the object, where the reflection of light is strongest. *Reflected light,* often overlooked by beginners, is surrounding light that is reflected into the shadowed area of an object.

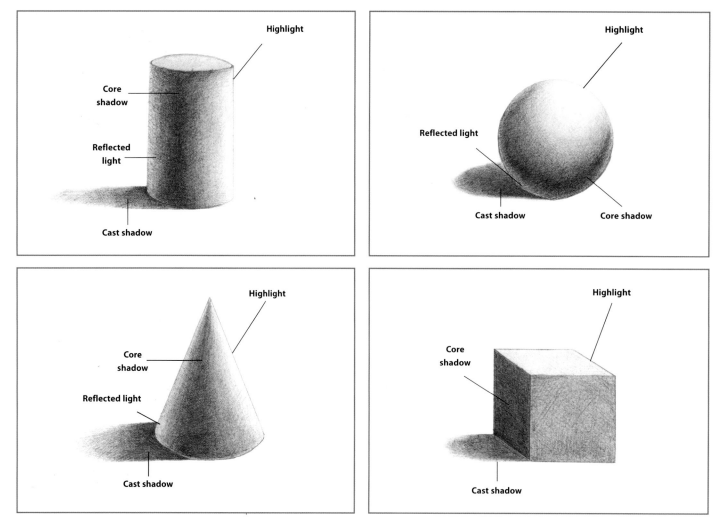

Creating Textures

Textures are not entities that exist on their own; they are attached to a form and are subject to the same basic rules as all other forms. A texture should be rendered based on how the light source affects it. Texture shouldn't be confused with pattern, which is the tone or coloration of the material. Blindly filling an area with texture will not improve a drawing, but using the texture to build a shadow area will give the larger shape its proper weight and form in space. You should think of texture as a series of forms (or lack thereof) on a surface. Here are some examples to help you.

Cloth The texture of cloth will depend on the thickness and stiffness of the material. Thinner materials will have more wrinkles that bunch and conform to shapes more perfectly. As wrinkles move around a form and away from the picture plane, they compress and become more dense.

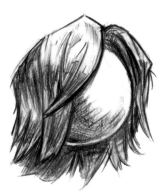

Long Hair Long hair, like cloth, has a direction and a flow to its texture. Its patterns depend on the weight of the strands and stress points. Long hair gathers into smaller forms—simply treat each form as it own sub-form that is part of the larger form. Remember that each form will be influenced by the same global light source.

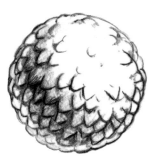

Scales Drawn as a series of interlocking stacked plates, scales will become more compressed as they follow forms that recede from the picture plane.

Wood If left rough and not sanded down, wood is made up of swirling lines. There is a rhythm and direction to the pattern that you need to observe and then feel out in your drawings.

Short, Fine Hair Starting at the point closest to the viewer, the hairs point toward the picture plane and can be indicated as dots. Moving out and into shadowed areas, the marks become longer and more dense.

Metal Polished metal is a mirrored surface and reflects a distorted image of whatever is around it. Metal can range from slightly dull as shown here to incredibly sharp and mirror-like. The shapes reflected will be abstract with hard edges, and the reflected light will be very bright.

Feathers and Leaves As with short hair, stiff feathers or leaves are long and a bit thick. The forms closest to the viewer are compressed, and those farther away from the viewer are longer.

Curly Hair With curly hair, it's important to follow the pattern of highlights, core shadow, and reflected light. Unruly and wild patterns will increase the impression of dreaded or tangled hair.

Rope The series of braided cords that make up rope create a pattern that compresses as it wraps around a surface and moves away from the picture plane.

Rendering Hair

There are many variations within each basic type of hair, but you should be able to adapt the techniques below to draw any hair type you wish.

Long, Curly Hair

Detail Method

Step 1 Long, curly hair tends to flow in waves. Begin drawing wavy lines using an HB pencil, roughly following a consistent pattern of curvature while ensuring that the pattern isn't too rigid and exact. Be sure to overlap some hairs for realism.

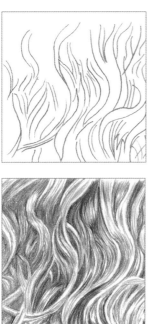

Step 2 Darken the areas in between the main clumps of hair using a soft pencil. Then suggest the strands within the clumps of hair nearest the viewer, using long strokes to communicate the length. Leave some areas nearly free of graphite to bring them forward visually.

Sketch Method

Step 1 To draw the same hair with a freer, looser style, don't worry about positioning the hairs or other details; just sketch long, wavy lines, again following a general S-shaped pattern.

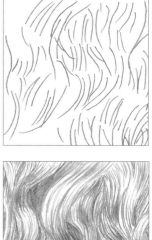

Step 2 Now rough in texture using lines. Rather than creating definite areas of highlights and shadows, simply place the lines closer together in shadowed areas and farther apart in lighter areas. When drawing any type of hair, always stroke in the direction of growth.

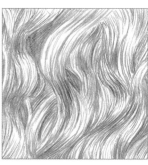

Long, Straight Hair

Detail Method

Step 1 Long, straight hair doesn't necessarily lay in perfectly parallel lines. In fact, the longer the hair, the more haphazard it's likely to be. With this in mind, draw long sections of hair, stroking in different directions and overlapping strokes.

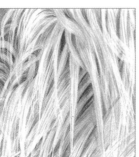

Step 2 Carefully shade the dark areas among the hairs, and apply long, light strokes on top of the sections of hair. Then use tack adhesive to lift out some individual hairs, giving depth to the coat.

Step 1 Draw light, rough, lines to provide guidelines for the sections of hair. Then use long, wispy strokes to gradually build up the strands along the guidelines. Place lines closer together for dark areas and farther apart for light areas.

Sketch Method

Step 2 As with the detailed method, add highlights and depth by lifting out additional hairs using tack adhesive formed to a point.

Colored Pencils

Colored pencil artwork is affordable to create and requires only a few supplies; however, it's helpful to purchase the best quality materials possible. If you invest in the good stuff, your artwork will last for many years after you create it.

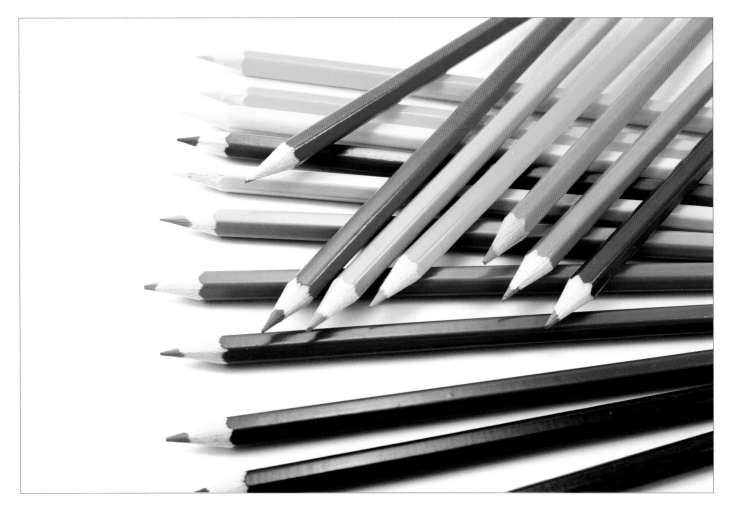

Pencils

You can purchase artist-grade colored pencils individually or in sets at art and hobby stores as well as online. There are three basic types of colored pencils: wax-based, oil-based, and water-soluble.

Wax-based pencils produce creamy, buttery textures and are a joy to work with. Sanford Prismacolors® are one of the most popular brands; they are sold in sets of up to 132 pencils.

Oil-based pencils use oil in their binders rather than wax. This results in fewer pencil crumbs and less sharpening. Faber-Castell® Polychromos (German) pencils and Caran d'Ache Pablo® (Swiss) pencils perform well in this category. Water-soluble pencils are bound with a water-soluble gum. They lend themselves to watercolor effects while still preserving the detail and precision of a pencil.

You can use wax-based and oil-based pencils interchangeably in your artwork; water-soluble pencils are best for the projects meant to convey a watercolor effect.

Colored Pencil Techniques

With colored pencils, you can create everything from soft blends to brilliant highlights to realistic textures. Once you get the basics down, you'll be able to decide which techniques will capture your subject's unique qualities.

Pressure

Colored pencil is not like paint: You can't just add more color to the tip when you want it to be darker. Because of this, your main tool is the amount of pressure you use to apply the color. It is always best to start light so that you maintain the tooth of the paper for as long as you can.

Light Pressure Here color was applied by just whispering a sharp pencil over the paper's surface.

Medium Pressure This middle range creates a good foundation for layering. This is also the pressure you might want to use when signing your drawings.

Heavy Pressure Really pushing down on the pencil flattens the paper's texture, making the color appear almost solid.

Layering and Blending

With colored pencil, color mixing and blending occurs directly on the paper. With layering, you can build up color or create new hues. To deepen a color, layer more of the same over it; to dull it, use its complement. You can also blend colors by burnishing with a light pencil or using a colorless blender.

Layering Blending involves layering one color directly over another. This can be done with as many colors as necessary to achieve the desired results. Use light pressure, work with a sharp pencil point, and apply each layer smoothly.

Burnishing with a Colorless Blender Burnishing requires heavy pressure to meld two or more colors together for a shiny, smooth look. Using a colorless blender tends to darken the colors, whereas using a white or light pencil lightens the colors.

Burnishing Light Over Dark You can also burnish using light or white pencils. To create an orange hue, apply a layer of red and then burnish over it with yellow. Remember to place the darker color first and try not to press too hard on the underlayers of the area you intend to burnish; if you flatten the tooth of the paper too soon, the resulting blend won't be as effective.

Optical Mixing Scumble, hatch, stipple, or use circular strokes to apply the color, allowing the individual pencil marks to look like tiny pieces of thread. When viewed together, the lines form a tapestry of color that the eye interprets as a solid mass. This is a very lively and fresh method of blending that will captivate your audience.

Strokes

Each line you make in colored pencil drawing is important—and the direction, width, and texture of the line you draw will contribute to the effects you create.

 (hatching)

Circular Move your pencil in a circular motion, either in a random manner or in patterned rows. For denser coverage, overlap circles. You can also vary the pressure throughout for a more random appearance.

Linear It may be more comfortable for you to work in a linear fashion: vertically, horizontally, or diagonally, depending on your preference. Your strokes can be short and choppy or long and even, depending on the texture desired.

Scumbling This effect is created by scribbling your pencil over the surface of the paper in a random manner, creating an organic mass of color. Changing the pressure and the amount of time you linger over the same area can increase or decrease the value of the color.

Hatching This term refers to creating a series of rough parallel lines. The closer the lines are together, the denser and darker the color. Crosshatching is laying one set of hatched lines over another but in a different direction. You can use both of these strokes to fill in an almost solid area of color, or you can use them to create texture.

Smooth Always strive to control the pencil so that you apply a smooth, even layer of color regardless of the technique you used to apply it.

Stippling This is a more mechanical way of applying color, but it creates a very strong texture. Simply sharpen your pencil and create small dots all over the area. Make the dots closer together for denser coverage.

Tracing and Transferring Images

Using a Light Box

A light box is a special desk or inexpensive box with a transparent top and a light inside. The light illuminates papers placed on top and allows dark lines to show through for easy tracing. After photographing and enlarging the line drawing (or sketching it on a piece of scrap paper), tape the sketch to the surface of the light box. Cover the sketch with a sheet of clean drawing paper and flip the switch—the light illuminates the drawing underneath and will help you accurately trace the lines onto the new sheet of paper. You can make your own light box by placing a lamp under a glass table, or you can even tape the sketch and the drawing paper to a glass window and use natural light.

Using Transfer Paper

Another easy method is to trace the image on a sheet of tracing paper and then coat the back of the tracing paper with an even layer of graphite. (Or you can purchase transfer paper, which already has one side coated with graphite.) Then place the tracing paper over a clean sheet of drawing paper, graphite-side down. Tape or hold the papers together and lightly trace your outline. The lines of your sketch will transfer onto the new sheet of drawing paper.

Using the Grid Method

This method helps you break the subject down into smaller, more manageable segments. First photocopy the line drawing and then draw a grid of squares (about 1") over the photocopied image. Then draw a corresponding grid over your drawing paper. The line drawing and the drawing paper must have the same number of squares. Once you've created the grids, simply draw what you see in each square of the line drawing in each square of the drawing paper. Draw in one square at a time until you have filled all the squares.

Checking your Lines While tracing the lines of the sketch, occasionally lift the corner of the sketch (and the coated tracing paper) to make sure the lines that have transferred to the drawing paper aren't too light or too dark.

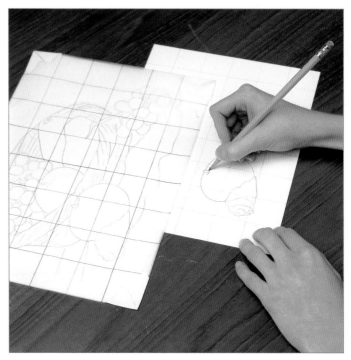

Making Grids Using the lines of the grid squares as reference points, you can accurately position the features of your subject. Make the grid lines light; you'll erase them when done.

CHAPTER 3
pastel

Introduction to Pastel

Although some artists argue over whether pastel is a painting or drawing medium, many agree that it combines the best of both worlds. It offers the color and richness of painting with the control of drawing—and because there is no brush or palette between you and the paper, you'll find it an intimate and tactile experience. The medium is extremely versatile in appearance; you can create delicate strokes, bold strokes, soft blends, rough textures, or airy sketches. And pastel involves no drying time, so colors stay as true as the moment you stroke, making it perfect for the spontaneous artist who treasures immediate results.

Pastels are powdered pigment mixed with a binder and packed into sticks. They are available in both hard and soft varieties, with the softer pastels containing a higher pigment-to-binder ratio. You can also find them in pencil form, which offers a clean alternative to sticks.

Oil pastels are much different from the "dry" pastels mentioned above. These oil-based sticks have a creamy consistency and yield more vibrant hues. They aren't used in combination with dry pastels; however, they can be used effectively alongside oil paints.

Paper is an important part of the pastel equation. No matter what type of pastel you choose, work on paper that has a textured surface so the raised areas catch and hold the pastel. You might also opt for toned (or colored) paper, which eliminates distracting bits of white from showing through your final piece.

Ready to Start?
Here's what you'll need: pastels (a 12-piece set is a fine start), textured paper,
soft rags for blending, blending stumps, drawing board or tabletop, and
newspaper to place beneath your textured pastel paper.

Pastel Basics

There are many choices of available pastels.

Soft pastels: Soft pastels are great for the undercoats of color, whether for the sky in the background or the horse's coat.

Too soft: A pastel may be too soft if it fills up too much of the *tooth* (grooves or dips) of the paper early on and prohibits additional colors from going down on top.

Hard pastels: Hard pastels are useful for creating detail, such as hair, whiskers, hooves, and blades of grass.

Too hard: A pastel may be too hard if it is very difficult to even tint the paper with the color.

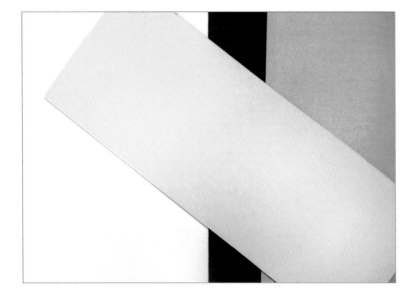

Velour paper

There are many wonderful papers to use with pastel. Try as many of them as you like. Then compare them to velour paper and see which you enjoy and feel the most comfortable using. Velour paper comes in many colors. You can buy it by the individual sheet and find the colors that best suit your style and personality. You can find velour paper at most big art supply stores and also through mail order.

◀ These scraps of velour paper are leftovers trimmed off a larger painting. Keep your scraps and experiment on them or use them for a smaller painting or study.

Black Construction Paper

While pastel doesn't smear as easily on velour paper as it does on other types, the oils and perspiration from your hand can change the nap of the paper. This will make the surface harsher and difficult to rework. To prevent this, cover the areas that are already finished with black construction paper to prevent damaging the artwork. Black construction paper is also helpful for creating a window around a difficult area, such as an eye. This focuses concentration on the area and prevents distraction.

▶ Black construction paper has several uses, such as protecting finished areas of the painting or creating a frame of focus for an area of detail as shown above.

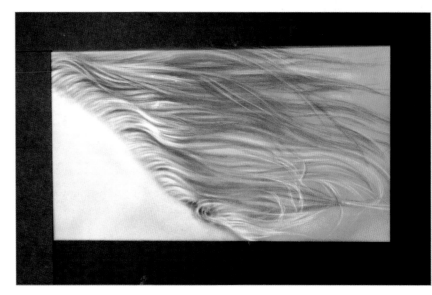

Pastel Techniques

Unlike painting with a brush, working with pastel allows you to make direct contact with the support. Therefore you have much more control over the strokes you make, the way you blend the pigment, and the final effects. Once you learn and practice the techniques shown here, you'll know which ones will give you the results you desire.

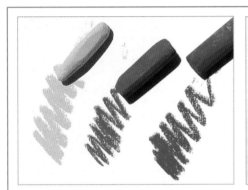

Firm Strokes Use the ends of the pastel sticks to create thick, bold strokes. The more pressure you apply, the thicker the stroke will be. These strokes are ideal for rendering large textured areas, such as fields of grass.

Side Strokes To quickly cover the support and fill in areas of broad color, drag the side of the stick across the support. This technique is effective for creating skies, water, and underpaintings.

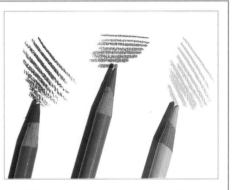

Pencil Lines Pastel pencils offer the most line control, as they are less likely to crumble or break than other types of pastel. If sharp, they can produce a very fine line, which is ideal for creating details or textures, such as fur or hair.

Experimenting with Strokes

The way you hold and manipulate the pastel stick or pencil will directly affect the resulting stroke. Some grips will give you more control than others, making them better for detail work; some will allow you to apply more pigment to the support to create broad coverage. The pressure you exert will affect the intensity of the color and the weight of the line you create. Experiment with each of the grips described below to discover which are most comfortable and effective for you.

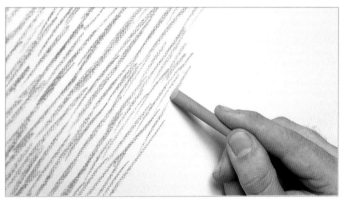

Linear Strokes To create linear strokes, grip the pastel stick toward the back end, and use your thumb and index finger to control the strokes. This grip is ideal for creating fine lines and details; however, it offers less control than the other grips.

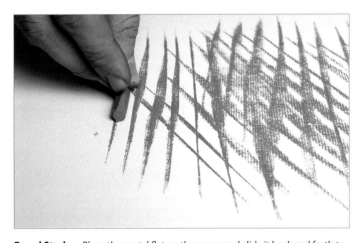

Broad Strokes Place the pastel flat on the paper and slide it back and forth to create broad linear strokes. This grip is also useful to create a "wash"; use the length of the pastel to cover large areas and create backgrounds quickly.

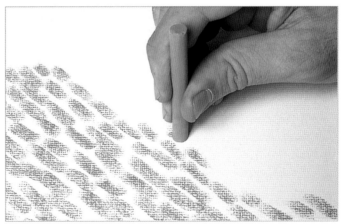

Round Strokes Turn the pastel stick on its end and grip it toward the front to create short, rounded strokes. This grip is perfect for creating texture quickly in large areas. Try overlapping the rounded strokes to create a denser texture.

More Pastel Techniques

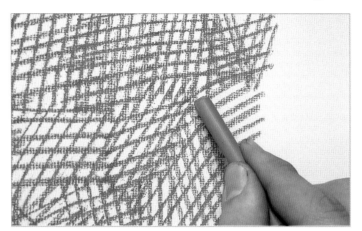

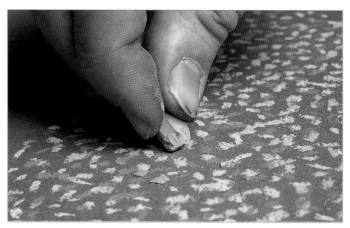

Crosshatching Hatched strokes are a series of parallel lines; crosshatched strokes are simply hatched lines layered over one another, but in opposite directions. You can crosshatch strokes of the same color to create texture or use several different colors to create an interesting blend.

Pointillism Another way to build up color for backgrounds or other large areas of color is to use a series of dots, a technique called "pointillism." This technique creates a rougher, more textured blend. When viewed from a distance, the dots appear to merge, creating one color.

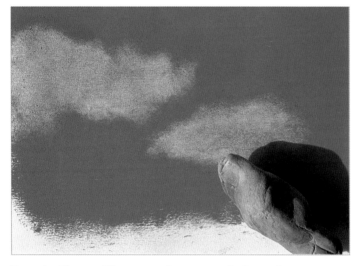

Removing Pigment When you need to remove color from a given area, use a kneaded eraser to pick up the pigment. The more pressure you apply, the more pigment will be removed. Keep stretching and kneading the eraser to expose clean, new surfaces.

Creating Patterns To create textures or patterns when rendering fabric or clothing, first lay down a solid layer of color using the side of the pastel stick or pencil. Then use the point of a pastel pencil to draw a pattern, using several different colors if you wish.

Using Tape You can create straight, even edges by using house painter's tape. Just apply it to your support, and make sure the edges are pressed down securely. Apply the pastel as you desire, and then peel off the tape to reveal the straight edges.

Gradating on a Textured Support Creating a smooth, even gradation on a textured ground can be a little tricky. Add the colors one at a time, applying the length of the stick and letting it skip over the texture of the paper by using light pressure.

Glazing Create a "glaze" just as you might with watercolor by layering one color over another. Use the length of the pastel stick with light pressure to skim over the paper lightly. The result is a new hue—a smooth blend of the two colors.

Blending Pastels

There are a number of ways to blend pastels, and the method you use depends on the effect you want to achieve and the size of the area you're blending. Smooth, even blends are easy to achieve with a brush, a rag, or even your fingers. You can also use your finger or a paper blending stump to soften fine lines and details. Still another method is to place two or more colors next to each other on the support and allow the eye to visually blend them together.

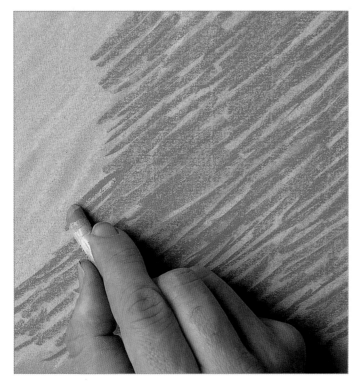

Applying Unblended Strokes In this example, magenta is layered loosely over a yellow background. The strokes are not blended together, and yet from a distance the color appears orange—a mix of the two colors.

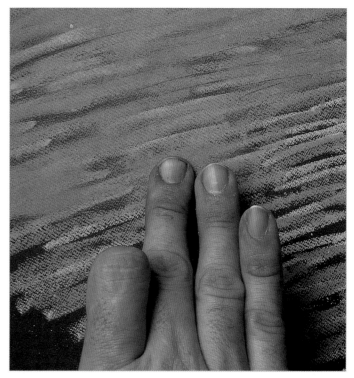

Blending with Fingers Using your fingers or the side of your hand to blend gives you the softest blend and the most control, but be sure to wipe your hands after each stroke so you don't muddy your work. Or use rubber gloves to keep your hands clean.

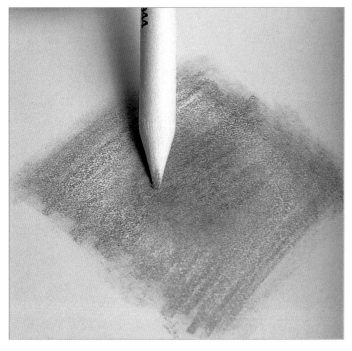

Blending with a Tortillon For blending small areas, some artists use a paper blending stump, or tortillon. Use the point to soften details and to reach areas that require precise attention.

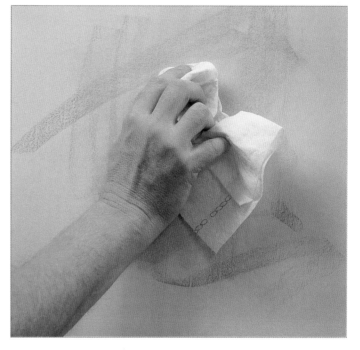

Using a Cloth For a large background, it is sometimes helpful to use a cloth or a paper towel to blend the colors. To lighten an area, remove the powdery excess pastel by wiping it off with a soft paper towel.

Shading with Pastel

Smooth Shading in Pastel

You can obtain a smooth look, such as shading for large areas of color, in your paintings by using the long side of a pastel. As you stroke the pastel onto velour paper, you want just a little color coming off the stick. That way the nap of the paper won't completely fill with pigment, and you will be able to add more colors and layers on top. To do this, lightly crosshatch the color back and forth across itself until you build up a smooth layer. As you add the next color, your pastel will press the layer underneath into the paper to help add depth.

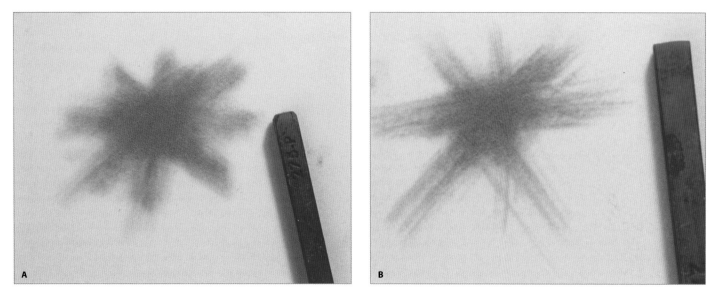

Shading with Hard Pastels Shading with an unsharpened hard pastel (A), you can achieve broader, softer strokes of color than with a sharpened hard pastel (B). Crosshatch the color in four different directions; the goal is for the area in the very center to be even and smooth with no edges or ridges of color showing as individual marks. It's a good idea to practice on scrap paper until you feel you are getting a very smooth look with your color.

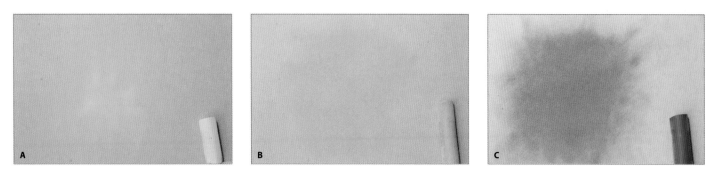

Shading with Soft Pastels Use a light touch when you work with soft pastels. Because they are softer, they naturally leave a lot more pigment on the paper. This demonstration shows you how to practice layering three different colors using smooth, crosshatching strokes with the side of your pastels. After you place the layer of yellow (A), you'll likely notice that the ripples of the paper show through the color. As you add the next layers of color, they will help push the yellow down into the nap of the paper for a smoother look. Next, cover the yellow with pink (B) and see how smooth the paper and layers now look. Then, add light purple on top (C) and, again, notice how this third layer covers the other colors and continues to smooth the surface.

Special Effects with Pastel

Masking

The dusty nature of pastel makes it difficult to create clean, hard edges; but employing a simple masking technique is a great way to produce sharp edges. To mask, use a piece of paper or tape to create a straight edge, or create a clean-edged shape with a special mask you make yourself. Of course, you would use tape only to save the white of the paper; never apply it to a support that already has pigment on it.

Cutting the Shape Begin by drawing the shape on a piece of tracing paper and cutting it out.

Applying the Color After painting the background, place the mask on top and then apply color.

Removing the Mask Carefully peel away the mask to reveal the crisp shape underneath.

Using a Combination of Techniques

These techniques are useful in and of themselves, but you won't truly understand the effects you can achieve until you apply them to an actual subject. Here you can see how the same subject is rendered using three different methods; notice the different look of each.

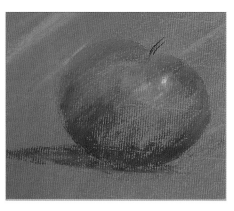

Linear Strokes Linear strokes are layered over one another to create a more textured appearance. From a distance, the colors still appear to blend together.

Blending Here the colors were applied thickly and smoothly. The even layers of color create the appearance of a slick, smooth object.

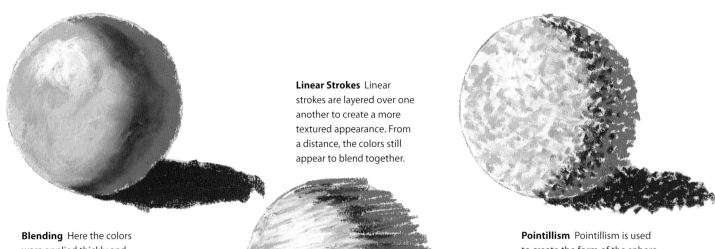

Pointillism Pointillism is used to create the form of the sphere. Although the same colors are used, the surface of the object appears much rougher.

Working with Oil Pastels

To begin working with oil pastels, you'll need a few basic supplies, listed below. While there are a number of techniques that can be achieved with this medium, the basics are shown here.

- Oil pastels: Vandyke brown, Prussian blue, gray, yellow, yellow orange, brown, white, black, pink, ultramarine blue, yellow ochre, olive brown, yellow green, vermillion, deep green, pale orange, green, Prussian blue, orange, lemon yellow, red, pale blue, cobalt blue, gray green, green gray, olive gray, and purple
- Acrylic paints: Ultramarine blue, burnt sienna, yellow ochre
- Graphite pencils

- Conté black pencil
- Kneaded eraser
- Paper
- Heavy rag
- Gamsol
- Gesso
- Matte medium
- Palette knife
- Ruler (to tear down paper to size)

Scraping Back First put down a layer of color. This example shows yellow green. Next, smudge this until it becomes a solid. Then, layer another color on top of it, such as cobalt blue, and smudge it until it becomes a solid. Now, you can scrape detail back into your piece. Use a penny nail to carve through the top layer of color to reveal the yellow green beneath.

Blending with Oil Pastel Begin by covering one area with yellow. Next, add a layer of vermillion hue next to the yellow. Then, press hard and blend with the oil pastel crayon, using pressure in the middle where the two colors meet.

Highlight A highlight is the chunk of light that is the lightest spot on your image. After creating your rendering, place the highlight appropriately. This grape was created with vermillion hue as a middle tone, Prussian blue for the shadow shape, and white for the highlight. The background is an even layer of yellow ochre with thick white on top.

Acrylic Toned Base First, mix a transparent layer of Ultramarine blue and matte medium. Next, use this to cover the surface. Then, create a gradient with olive brown— the pressure of application determines intensity. Notice the difference between opacity and optical blending.

Smudge with Finger Put down an even layer of purple. On top of that, place a layer of yellow ochre, and then smudge/blend with your finger. Strive for even color.

Blending with Turpentine First, crosshatch a layer of green. Then, layer an even color application of lemon yellow on top. Finally, blend with a large flat brush, using a little Gamsol or Turpentine to create an even color.

Stippling Start with pale blue. Create an even tone by making dots over the entire surface. Next, begin on one side and stipple Prussian blue until you've made a gradual value shift like shown in the example.

Draw Back Into Begin by cross-hatching an even layer of color with orange. Next, use a Conte or Derwent® black pencil to draw on top of the orange, thus creating detail. You can also do this with graphite.

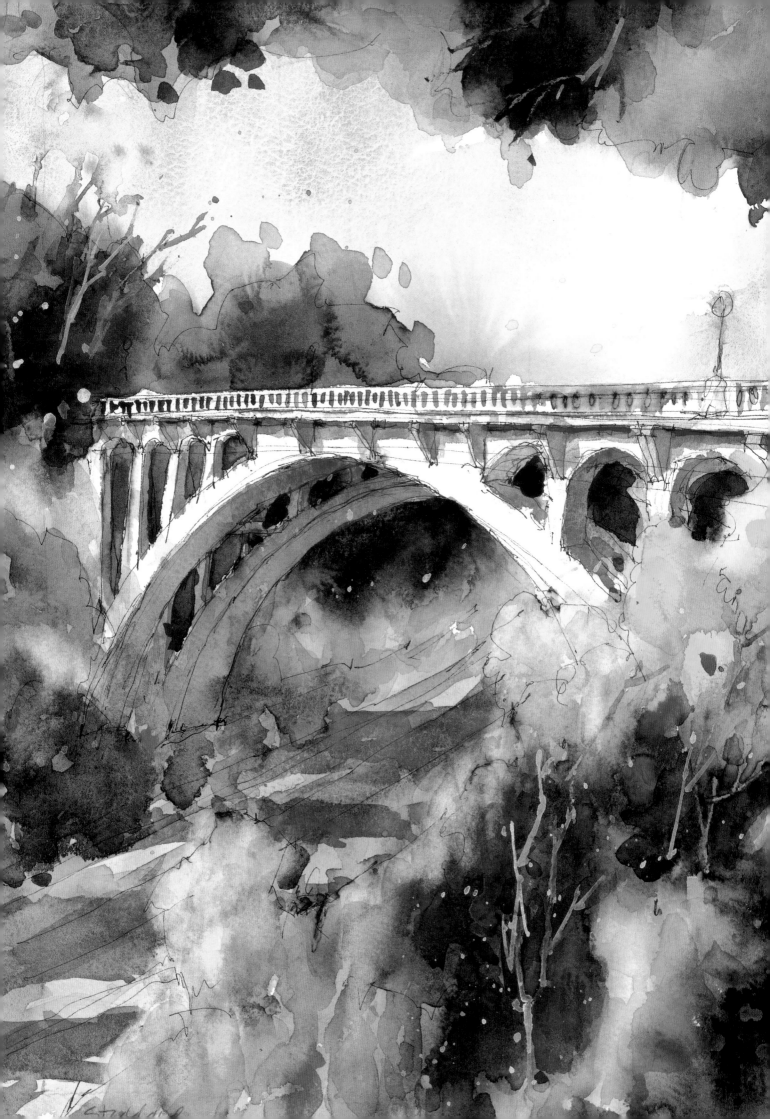

100 things every artist should know

CHAPTER 4
watercolor

Introduction to Watercolor

"What a splendid thing watercolor is to express atmosphere and distance, so that the figure is surrounded by air and can breathe in it, as it were." —Vincent van Gogh

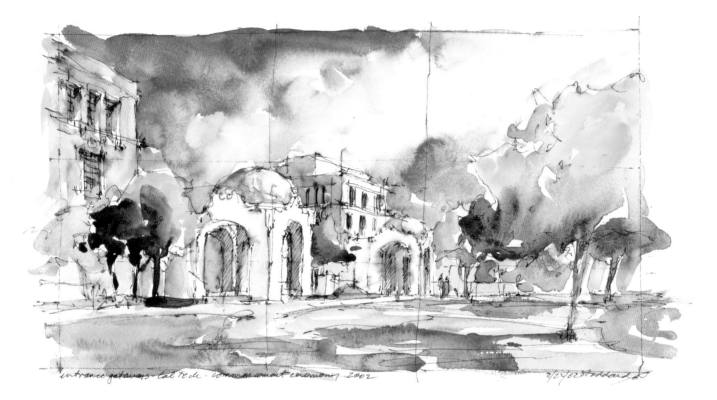

entrance gateways, Cal Tech - commencement ceremony 2002

Van Gogh had it right—the airy and atmospheric qualities of watercolor set it apart from all other painting media. Made up of pigment suspended in a binder of gum arabic, watercolor is a fluid medium that requires quite a bit of practice to master. (And even once you've learned to control the moisture, be open for a bit of spontaneity!) However, if you devote enough time to this medium, you'll understand why it is praised for its ability to quickly capture an essence, suggesting form and color with just a few brushstrokes.

Watercolor paints come in a few forms, so experiment to find the kind that suits you best. Collapsible metal tubes are the most common form, which release moist, goopy paint. Mix a small pea-sized amount of this with water to create a wash. Dry pans (small blocks of dry pigment) and semi-moist pots are other forms of watercolor. To use these, simply stroke over the pigment with a wet brush. Pans and pots are considered more convenient for painting on location because they are less watery and often come in closeable palettes.

Unlike other painting media, watercolor relies on the white of the paper to tint the layers of color above it. Because of this, artists lighten watercolor washes by adding water—not by adding white paint. To maintain the luminous quality of your watercolors, minimize the layers of paint you apply so the white of the paper isn't dulled by too much pigment.

Ready to Start?
Here's what you'll need: set of watercolor paints, two jars of water, set of brushes, mixing palette (with wells), paper towels, watercolor paper, masking tape, drawing or painting board, and a sketching pencil.

Tools and Materials

Paints

There are many schools of thought that suggest using only limited color palettes and mixing all other colors, but it will save time if you already have the colors you need. It is always better to have really good quality paint, the best you can afford. The less expensive student brands are fine for beginners.

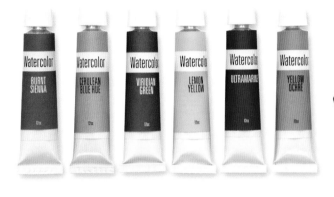

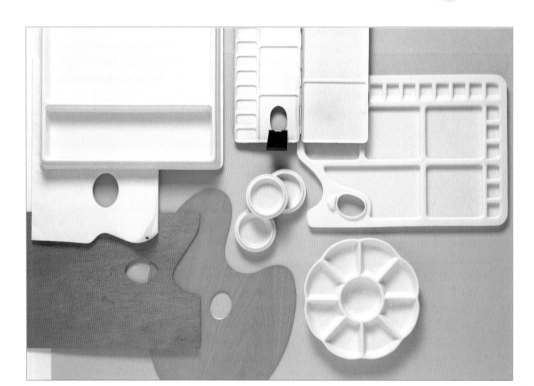

Palette

A plastic palette with at least a few wells will work, but heavier plastic will last longer and survive daily wear and tear. You'll want enough smaller wells to hold the colors you are going to use the most. For paintings with large areas of color, your palette will also need mixing areas big enough to hold large amounts of paint. It's even possible to use a white dinner plate for mixing colors.

It's important to periodically wipe down your entire palette with paper towels or tissues to prevent your colors from getting muddy.

Preparing Watercolor Paper

To stretch watercolor paper the old-fashioned way, you'll need a piece of plywood, a light duty staple gun, and a pair of beveled pliers. You may also want to use a lamp (not fluorescent) or hair dryer to speed the drying process.

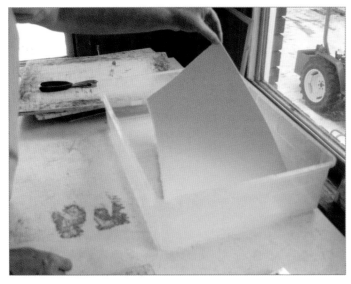

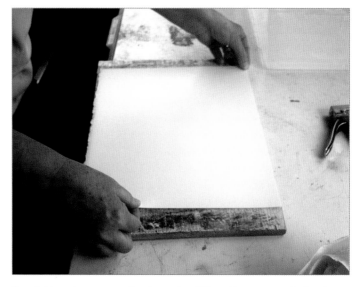

Step 1 Begin by soaking the paper in tepid water in a large tray for about 10 minutes. To remove the paper, grab it by one corner and hold it up to let the excess water drain.

Step 2 Place the paper on the plywood and blot with paper towels. Gently pull the paper diagonally across the long sides and place two staples near the center on the outer edge of each short side.

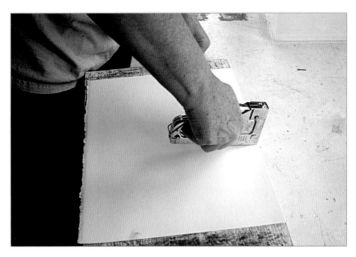

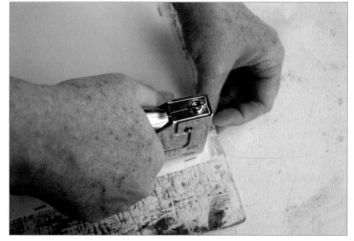

Step 3 Grab one corner and pull diagonally. Hold the paper in place and put one staple on each side of the corner. Repeat for the other three corners.

Step 4 Continue stapling along the outer edges until you've placed about eight staples per 14" side.

Step 5 Gently blot more water out of the paper and place somewhere to dry for about 24 hours before painting. Once your finished painting is dry, gently remove the staples with your pliers. Trim off the stapled edges with a paper cutter.

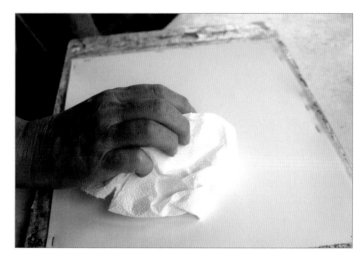

Watercolor Techniques

Here are some ways you can apply and manipulate watercolor paint.

Flat Wash For this basic technique, cover your paper with horizontal bands of even color, starting at the top and working your way down.

Graduated Wash Load your brush and apply overlapping strokes, adding water with each consecutive stroke. The color will gradually thin out as you continue.

Soft and Hard Lines For a hard line, paint a dry stroke on dry paper. Any line can be softened by blending the edge with clear water before it dries. This is useful for areas where detail is not needed.

Spattering Hold a loaded brush over your paper and lightly tap the brush with your finger. This can also be done with clear water over a still-wet color. (Practice this technique before applying it to a painting.)

Negative Painting Negative painting involves painting around the desired shape rather than painting the shape itself. Instead of painting a leaf, paint the area around the leaf.

Salt Using salt with watercolor can create sparkly effects or a mottled texture. Simply sprinkle salt over a freshly wet wash. When dry, gently rub off the salt.

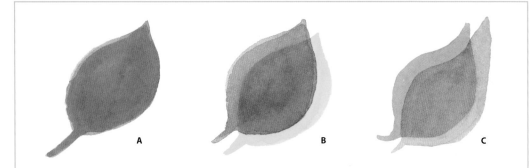

A B C

Color Glazing Rather than mixing each color, it's possible to layer transparent colors to create a new color. This technique, called "glazing," adds a distinct glow and depth to your painting because the color is mixed optically on the paper (B) rather than in the palette (A). Let each layer dry before adding another color. Also, it's important not to use a brush that's too wet, or you may disturb the previous layers. In addition to color mixing, you can darken areas that stand out too much by glazing over them. Any complementary color glazed over another (C) will make the color darker. You can do the same using a cool color (blues, greens, and purples) over a warm color (reds, oranges, and yellows) or vice versa.

Masking Fluid Masking fluid is liquid latex that allows you to protect areas that you want to remain white in an otherwise dark picture. Paint the area you want with the masking and let it dry. To remove it, rub it off with your fingers. Since it can be difficult to remove from brushes, use an old brush or a rubber-tipped brush for thin lines.

Mixing Watercolors, Part 1

Painting with transparent watercolors is a unique and enjoyable experience because of the way the colors can be mixed. Other types of paint (especially oil) are usually mixed on a separate palette and then applied to the canvas. They are also mixed additively; in other words, white pigment is added to lighten the colors. In contrast, transparent watercolor relies on the white of the paper and the translucency of the pigment to communicate light and brightness. A well-painted watercolor seems to glow with an inner illumination that no other medium can capture.

The best way to make your paintings vibrant and full of energy is to mix most of your colors on the paper while you are painting the picture. Allowing the colors to mix together on the paper, with the help of gravity, can create dynamic results. It is accidental to a certain degree, but if your values and composition are under control, these unexpected color areas will be very exciting and successful.

Wet on Dry
This method involves applying different washes of color on dry watercolor paper and allowing the colors to intermingle, creating interesting edges and blends.

▶ **Mixing in the Palette vs. Mixing Wet on Dry** To experience the difference between mixing in the palette and mixing on the paper, create two purple shadow samples. Mix ultramarine blue and alizarin crimson in your palette until you get a rich purple; then paint a swatch on dry watercolor paper (near right). Next paint a swatch of ultramarine blue on dry watercolor paper. While this is still wet, add alizarin crimson to the lower part of the blue wash, and watch the colors connect and blend (far right). Compare the two swatches. The second one (far right) is more exciting. It uses the same paints but has the added energy of the colors mixing and moving on the paper. Use this mix to create dynamic shadows.

▶ **Mixing a Tree Color** Next create a tree color. First mix green in your palette using phthalo blue and new gamboge, and paint a swatch on your paper (near right). Now create a second swatch using a wash of phthalo blue; then quickly add burnt sienna to the bottom of this swatch. While this is still wet, add new gamboge to the top of the swatch. Watch these three colors combine to make a beautiful tree color that is full of depth (far right).

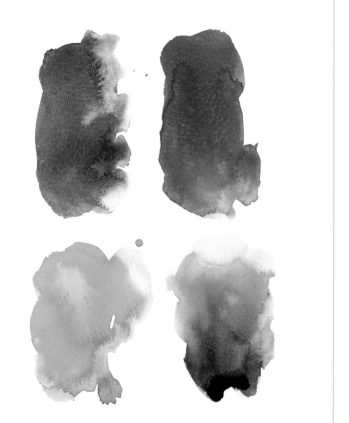

Variegated Wash
A variegated wash differs from the wet-on-dry technique in that wet washes of color are applied to wet paper instead of dry paper. The results are similar, but using wet paper creates a smoother blend of color. Using clear water, stroke over the area you want to paint and let it begin to dry. When it is just damp, add washes of color and watch them mix, tilting your paper slightly to encourage the process.

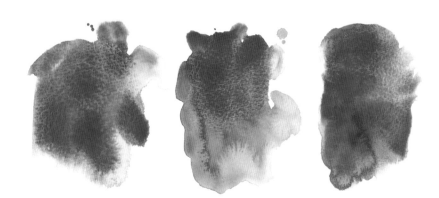

Applying a Variegated Wash After applying clear water to your paper, stroke on a wash of ultramarine blue (left). Immediately add some alizarin crimson to the wash (center), and then tilt to blend the colors further (right). Compare this with your wet-on-dry purple shadow to see the subtle differences caused by the initial wash of water on the paper.

Mixing Watercolors, Part 2

Wet into Wet

This technique is like the variegated wash, but the paper must be thoroughly soaked with water before you apply any color. The saturated paper allows the color to spread quickly, easily, and softly across the paper. The delicate, feathery blends created by this technique are perfect for painting skies. Begin by generously stroking clear water over the area you want to paint, and wait for it to soak in. When the surface takes on a matte sheen, apply another layer of water. When the paper again takes on a matte sheen, apply washes of color and watch the colors spread.

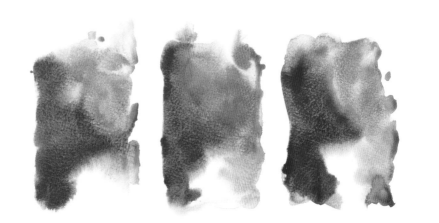

Painting Skies Wet into Wet Loosely wet the area you want to paint. After the water soaks in, follow up with another layer of water and wait again for the matte sheen. Then apply ultramarine blue to your paper, both to the wet and dry areas of the paper. Now add a different blue, such as cobalt or cerulean, and leave some paper areas white (left). Now add some raw sienna (center) and a touch of alizarin crimson (right). The wet areas of the paper will yield smooth, blended, light washes, while the dry areas will allow for a darker, hard-edged expression of paint.

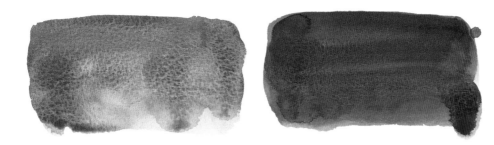

Creating a Glaze To create a glazed wash, paint a layer of ultramarine blue on your paper (far left). Your paper can either be wet or dry. After this wash dries, apply a wash of alizarin crimson over it (near left). The subtly mottled purple that results is made up of individual glazes of transparent color.

Glazing

Glazing is a traditional watercolor technique that involves two or more washes of color applied in layers to create a luminous, atmospheric effect. Glazing unifies the painting by providing an overall underpainting (or background wash) of consistent color.

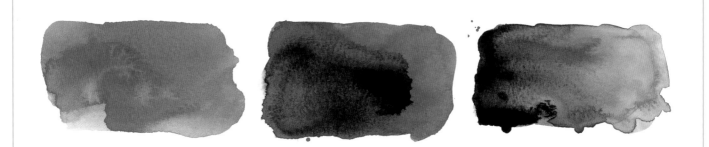

Charging In Color

This technique involves adding pure, intense color to a more diluted wash that has just been applied. The moisture in the wash will grab the new color and pull it in, creating irregular edges and shapes of blended color. This is one of the most fun and exciting techniques to watch—anything can happen!

Creating a Charged-in Tree Color First apply a wash of phthalo blue (left); then load your brush with pure burnt sienna and apply it to the bottom of the swatch (center). Follow up with pure new gamboge on the opposite side, and watch the pigments react on the paper (right). Remember that pigments interact differently, so test this out using several color combinations.

Watercolor Pencil Strokes

Watercolor pencil is very versatile, allowing you to create everything from soft, even blends to rough textures and intricate patterns. There are four basic approaches to using watercolor pencil. The first is to apply it as you would regular colored pencil and then blend the colors with a paintbrush and water. Another method is to create a "palette" by applying the pigment to a piece of scratch paper and then scrubbing a wet brush over it to pick up the color. You can also break off the tip of a sharp pencil and place it in a small amount of water to create a pool of color. Or you can dip a pencil in water until the pigment softens, rub it over the bristles of a brush, and apply the color to the support. Below are a number of ways to make the most out of your watercolor pencils.

Strokes

When you choose a subject to render in watercolor pencil, you'll also need to determine the weight, direction, and intensity of the strokes you'll use to make the most accurate representation. Try making strokes in different directions, varying the pressure, and alternately using the point and side of your pencil. Then go a step further by blending the pigment with a damp brush—your strokes will still be apparent but softened and more diffuse.

Left Diagonal Stroke You can fill in large areas with left-slanting diagonal strokes. Here they were blended in the middle with a wet flat brush.

Right Diagonal Stroke This is the same example as at left but with right-leaning strokes. You'll get better coverage with this stroke if you're right-handed.

Vertical Stroke This stroke can give you more even coverage, but it can be tedious. Be sure not to slant your strokes — your hand may get tired!

Overlapping Strokes You can mix colors by overlapping two hues and blending them with water. Here right diagonal strokes of green were layered over vertical strokes of blue.

Circular Strokes Straight lines aren't the only way to fill in color. On the left above, color was applied in tiny, overlapping circles. On the right, larger circles created more texture.

Bundling To create interesting texture or patterns, "bundle" small groups of linear strokes together. Note that the closer together the lines are, the more intense the resulting color.

Hatching Hatches are parallel lines used to suggest texture, create form, and build up color. Overlapped lines in opposite directions are crosshatches.

Pointillism You can also apply color with small dots made with the pencil point (called "pointillism"). The tighter the dots are, the deeper the hue.

Stippling Although stippling is often thought of as a brush technique, you can also stipple with a pencil;. use small dots and dashes to color small areas.

Watercolor Pencil Techniques: Pressure & Blending

Pressure

The amount of pressure you use on the pencil determines the intensity of color you produce. The more pressure you apply, the more intense the color will be. Please note that very firm pressure is not generally recommended for water-soluble pencils, as the pigment tends to clump if applied too heavily.

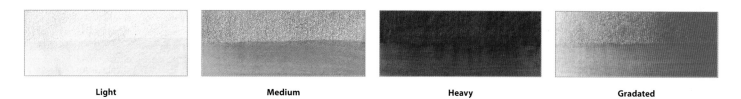

Light **Medium** **Heavy** **Gradated**

Using pressure Here you can see the difference between light, medium, and heavy pressure, as well as a gradated example—varying the pressure from left to right. The bottom half of each example has been brushed with water.

Blending

Working with watercolor pencil gives you a unique opportunity to mix and blend colored pencil pigments—you don't need to restrict yourself to overlapping layers and layers of color, as water can mix the hues. Adding water also allows you smooth your strokes or create special effects that wouldn't be possible with regular colored pencil. Below are just some of the ways you can blend and manipulate both dry and wet watercolor pencil pigments.

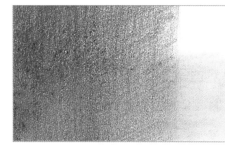

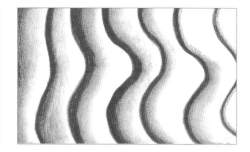

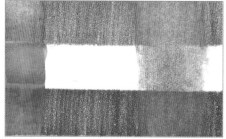

Hand Blending Here dry watercolor pencil was applied with varying amounts of pressure from left to right; then the bottom was blended by hand. Make sure your hands are warm, and then use your fingers and a circular motion to blend or smudge small areas.

Tool Blending In addition to using your fingers, you can utilize tools to blend the pigment. The red lines above were blended slightly with a cotton swab (on the left) and with a paper blending stump (on the right). Both tools create smoother smudges than you'd get by hand.

Color Mixing This example shows two wet methods for blending and mixing color: with water, as shown on the left, or with alcohol, as shown on the right. As you can see, the alcohol doesn't thoroughly dissolve all the pigment, so it produces a coarser-looking blend.

Dry Pencil In the top section, dry watercolor pencil was applied to dry paper; it looks the same as regular colored pencil. In the bottom half, the paper was wet first, and then the dry pencil applied. Notice that the lines over the wet paper appear blurry.

Wet Pencil In this example, the tip of the water-soluble pencil was dipped in water before being applied to the dry paper; then clear water was brushed down the stripe just off-center. Notice how much more intense the pigment is when wet.

Shavings This mottled texture was created by dropping pencil shavings onto the wet paper. Then, on the left side of the example, the pigment was rubbed into the paper by hand. The right side was spritzed with water to let the pigment dissolve naturally.

Special Effects

Because watercolorists generally use the white of the paper for the lightest areas of their paintings (rather than using white paint), it's important to "save" these areas from color. There are several methods you can use either to protect your white areas from color or to lighten areas where color has been applied.

Painting Around White Areas

One way to save the white and light areas of your paper is to simply paint around those areas of your subject. It helps to wet the paper where you want to paint, keeping dry the area you're painting around. The dry area stops the bleed and flow of the wet paint, protecting the white and light areas from receiving paint.

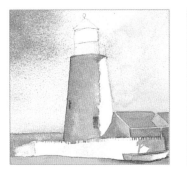

Painting around whites Here you can see the progression of a painting where the artist employed the technique of painting around whites. At an earlier stage in her painting (shown at left), the artist decided that the white picket fence and the right side of the lighthouse should receive the lightest values, so she simply painted around those areas. The example at right shows the final result.

White Gouache

Gouache is similar to watercolor (it is water-based), but it contains an ingredient that makes it more opaque. Some artists use white gouache to create or restore white areas in their watercolor paintings, as it can give light areas a more vibrant look. Gouache is also great for adding small highlights, such as in the pupil of an eye, or fine details, such as animal whiskers. Use a brush to paint white elements of your painting or to cover small mistakes.

Softening Details To create soft white details such as these water ripples, dampen a brush and dip it into slightly diluted white gouache; then paint over an area of already dry paint. The white gouache will sink softly into the underlying color, creating a slightly blurred effect.

Saving and Retrieving Whites

The white of the paper is very valuable to watercolorists. Below are some other ways to "save" and "retrieve" whites on paper.

Masking Fluid This rubbery substance can mask whites. Apply the mask, paint over it, and then rub off the mask when the paint is dry.

Lifting Color with Masking Protect the surrounding color with artist's tape, then lightly scrub with a damp sponge to remove color.

Scraping with a Razor For small areas, you can apply a razor to already-dried paint to gently scrape off lines of surface color.

Lifting Color without Masking Using a stiff brush loaded with clean water, gently scrub the paper to remove color.

Scraping with a Knife When damp paper has just lost its shine, you can use a palette knife to scrape off color.

Rendering Edges

Vary Edges

The most interesting paintings have varied edges. A painting done completely wet into wet will have all soft edges, resulting in a mushy look without any focus. And a painting with only hard edges will be busy and sharp, making it difficult to look at. Combining different kinds of edges gives depth, focus, and interest to the subject matter. Varying edges also produces a finished piece that is both more realistic and more interesting.

▶ **Distinguishing Edge Types** Varied edges aren't limited to painting—they're a part of life. In this photo, you can pick out hard edges, soft edges, and even lost edges (where an edge merges with an adjacent edge).

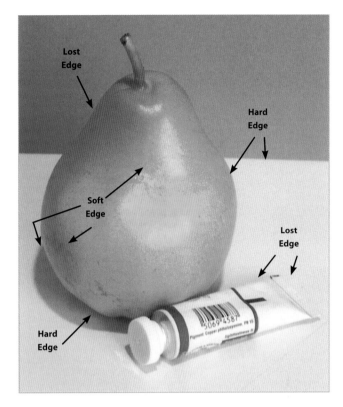

Hard Hard edges suggest structural, angular, and mechanical subjects. To make a hard edge, apply wet paint to dry paper.

Textured Broken edges define rough objects and can be used anywhere. Create them by dragging a lot of paint and minimal water across the paper with a brush.

Soft Soft edges produce rounded, diffused areas. For soft edges, paint wet into wet, soften a freshly painted edge with clean water, or lift out color.

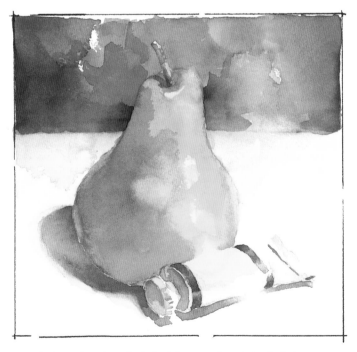

Varied Edges This subject looks lively because the painting includes a combination of hard edges, soft edges, and lost edges. Find the edges yourself. (They've changed a bit from the photo! Remember, the eye sees differently than the camera does.)

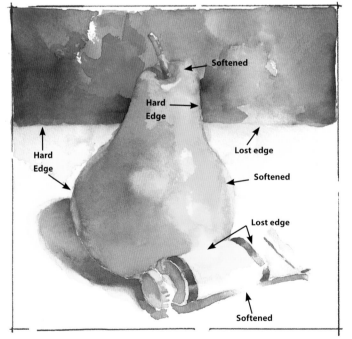

Edges Revealed How did you do? The white tube of paint is on a white surface, which allows for many lost edges. The pear is a little more difficult because you don't see the lost edges right away. When you have two areas that are close in value, squint and you'll see that the edge disappears. Once you can identify various types of edges, it will be easier for you to create them.

CHAPTER 5

oil and acrylic

Introduction to Oil

Often described affectionately with words like rich and buttery, this classic painting medium is a favorite among fine artists. The paint consists of ground pigment suspended in oil, which traps light and creates a luminous effect on the canvas. The slow-drying properties of oil allow artists to create smooth blends and rework their paintings over multiple sessions. This large window for manipulating and refining a work of art can result in an impressive degree of realism.

Oil painting is notoriously messy and calls for quite a few materials. Because it's not a water-based medium, you'll need special solvents for thinning the paint and cleaning your brushes. You can use either turpentine or mineral spirits for this—but keep in mind that these liquids are toxic and cannot simply be poured down a drain. Also, be sure to work in a well-ventilated room, as oil paints and solvents emit strong fumes.

Now that you're sufficiently intimidated by oil painting, experience it for yourself. You might just find it as alluring as the great masters did.

Ready to Start?

Here's what you'll need: set of oil paints, solvent, glass jars for holding solvent, mixing palette, palette knife, set of bristle brushes, small soft-hair brushes for detailing, linseed oil, primed and stretched canvas, rags, and artist's easel.

Introduction to Acrylic

What started as a house paint in the first half of the 20th century has become a respected medium for the fine artist. Acrylic paint, which is made up of pigment and acrylic polymer, boasts a number of positive qualities that make it a viable competitor to oil and watercolor. First, you can dilute the paint with plain water (no harsh solvents needed!), but once it's dry, the paint is waterproof. Second, you can apply the paint in thick or thin layers, imitating either oil or watercolor, respectively. Third, acrylic is resistant to cracking and fading. Fourth, unlike oil, acrylic dries quickly so you don't have to wait long between applying layers. Fifth, you can apply acrylic to nearly any surface (so long as it's not waxy or greasy), making it perfect for use in collage. And the list goes on.

Here are just few things to keep in mind while using acrylic. Because it dries quickly, you'll need to work quickly. This can be seen as a positive or negative quality depending on your painting style—for some it interferes with blending, but for others it encourages loose and lively strokes and discourages overworking. Also, it's important to note that acrylic paints often dry darker than they appear when wet.

Ready to Start?

Here's what you'll need: a set of acrylics, heavy paper or canvas, a set of synthetic brushes, two jars of water (one for rinsing the brushes and one for adding fresh water to mixtures), paper towels, and mediums.

Oil Tools and Materials

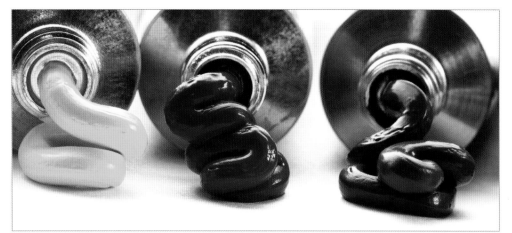

Oil Paint There are several different grades of oil paint, including student grade and artist grade. Artist-grade paints are a little more expensive, but they contain better-quality pigment and fewer additives. The colors are also more intense and will stay true longer than student-grade paints.

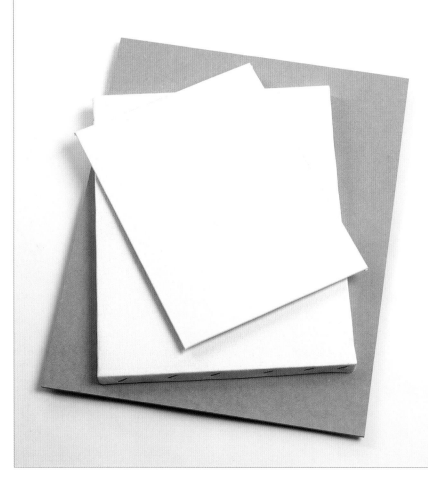

Fixative A fixative helps "set" a drawing and prevents it from smearing. Varnishes are used to protect paintings. Spray-on varnish temporarily sets the paint; a brush-on varnish permanently protects the work. Read the manufacturer's instructions for application guidelines.

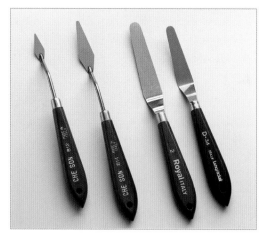

Supports Oil painting supports usually consist of canvas or wood. You can stretch canvas yourself, but it's much easier to purchase prestretched, primed canvas (stapled to a frame) or canvas board (canvas glued to cardboard). If you choose to work with wood or any other porous material, you must apply a primer first to seal the surface so the oil paints will adhere to the support.

Other Oil Painting Essentials

Other oil painting tools you may need include additives to thin out your paint (linseed oil) or to speed drying time (copal), glass or metal containers for additives, an easel, turpentine for cleaning your brushes, paper towels, and a mixing palette.

Painting and Palette Knives Palette knives can be used to mix paint on your palette or as a tool for applying paint to your support. Painting knives usually have a smaller, diamond-shaped head; palette (mixing) knives usually have a longer, more rectangular blade. Some knives have raised handles, which help prevent you from getting paint on your hand as you work.

Acrylic Tools and Materials

To get started with acrylic, you need only a few basic tools: paints, brushes, supports, and water. When you buy your acrylic supplies, remember to purchase the best you can afford at the time, as better-quality materials are more manageable and produce longer-lasting works.

Selecting Paints

Acrylic paints come in jars, cans, and tubes. Most artists prefer tubes, as they make it easy to squeeze out the appropriate amount of paint onto your palette. There are two types of acrylic paints: "student grade" and "artist grade." Artist-grade paints contain more pigment and less filler, so they are more vibrant and produce richer mixes.

Purchasing a Palette

Palettes for acrylic paints are available in many different materials—from wood and ceramic to metal and glass. Plastic palettes are inexpensive, and they can be cleaned with soap and water. Disposable paper palette pads are also very convenient; instead of washing away the remains of your paint, you can simply tear off the top sheet to reveal a fresh surface beneath.

Gathering the Basics

To get started, you'll want to have a few household materials on hand. You'll need two jars of water: one for adding to your paint mixes and one for rinsing out your brushes. A spray bottle will help keep the paints and mixes on your palette moist, and paper towels or rags will help with clean up.

Choosing Your Colors

A good beginner's palette of colors consists of one warm and one cool version of each of the primary colors: yellow, red, and blue. You'll also want to include white, black, and a few browns, such as burnt sienna or raw umber. From these basics, you should be able to mix just about any color you'll need. A basic palette generally consists of the following 17 colors: alizarin crimson, burnt sienna, yellow ochre, Naples yellow, pink (or flesh), dioxazine purple, cadmium red light, cadmium yellow light, unbleached titanium, titanium white, sap green, emerald green, Prussian blue, phthalocyanine (abbreviated phthalo) blue, Payne's gray, light blue (or cerulean blue), and light blue-violet.

Payne's Gray • Prussian Blue • Sap Green • Dioxazine Purple • Alizarin Crimson • Light Blue • Phthalo Blue • Emerald Green • Cadmium Red Light • Burnt Sienna • Light Blue-Violet • Cadmium Yellow Light • Yellow Ochre • Unbleached Titanium • Naples Yellow • Titanium White • Pink (or Flesh)

Supports

Acrylic paint will adhere to just about any surface, or support, as long as it's slightly porous and isn't greasy or waxy. Most acrylic artists use canvas or canvas board that has been primed (coated with gesso, a material used for sealing and protecting fabric and wood supports to make them less porous). It's easiest to purchase preprimed canvas, but you also can buy raw canvas and a jar of gesso and prime the canvas yourself. Be sure to use an old brush (a house-painting brush works well) when priming your own canvas. Watercolor papers and illustration boards also work well with acrylic paint and provide a smoother working surface. And primed pressed-wood panels—which generally have a smooth side and a rough side—are another popular option.

Illustration Board

Illustration board is good-quality, sturdy cardboard with a simulated canvas surface. It can be used with acrylic, watercolor, pencil, and ink. Illustration boards come with paper mounted on the back to prevent buckling and are available in a variety of sizes and weights.

Illustration Board
This example shows acrylic applied to illustration board as a thin wash (left) and in thick strokes (right).

Canvas

Ready-made canvases are available in dozens of sizes and come either stretched on a frame or glued on a board. Canvases usually are made of either linen or cotton and typically come preprimed. Make sure that your preprimed canvas does not have an oil primer on it, as acrylic paint doesn't adhere to this slick substance.

Painting on Canvas
This example shows acrylic applied to canvas in thick strokes (left) and as a thin wash (right).

Hardwood Panel

Pressed-wood panels are available "tempered" and "untempered"—be sure to choose untempered boards, as the tempered panels have been treated with oil, which isn't compatible with acrylic paints. Preprimed pressed-wood panels are available in a range of shapes and sizes at your local art supply store.

Painting on Rough Hardwood Panel Using the textured side of a pressed-wood panel will result in a rougher, more tactile painting. This example shows acrylic paint applied to rough hardwood panel in thick strokes (left) and as a thin wash (right).

Painting on Smooth Hardwood Panel Using the smooth side of a pressed-wood panel produces finer, more detailed brushstrokes. This example shows acrylic paint applied to smooth hardwood panel in thick strokes (left) and as a thin wash (right).

Stretching and Priming Canvas

Primer A primer acts as a barrier between the support and the paint. It is easy to prepare unprimed (raw) surfaces with three coats of a professional-grade gesso. Less expensive student-grade gesso tends to be too rough, and the paint tends to sink in. For some paintings it may be helpful to tint the final coat of gesso by mixing in acrylic paint. A light sanding before and after each coat of gesso ensures a stable and smooth painting surface.

Canvas You can purchase your canvas primed and pre-stretched. When working with unusual sizes, you can stretch the canvas yourself using canvas pliers and a stapler. For paintings larger than 20" x 24", use medium-duty stretcher bars with a good "lip" edge to keep the painting surface well separated from the inside edge of the stretcher bar. This prevents the stretchers from leaving an impression on the canvas (called "ghosting").

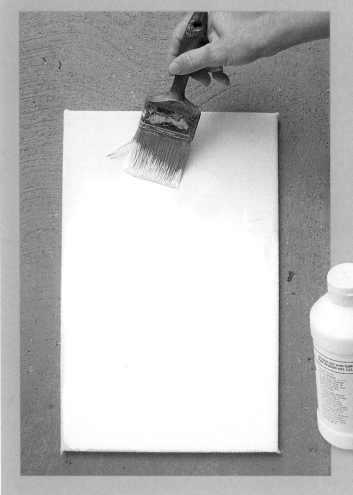

Priming Your Support

Preprimed supports are readily available at any art store, but you may prefer to prime the canvas or board yourself. To do this, you will need a hardwood board or stretched canvas, a jar of acrylic gesso, and a 2"-wide brush (a house painting brush works well).

Pour gesso directly on the support, and spread it evenly with the paintbrush, stroking alternately back and forth and up and down until the surface is smooth. (For a more textured surface, don't smooth out all the brushstrokes completely.)

Basic Techniques

There are myriad techniques and tools that can be used to create a variety of textures and effects. By employing some of these different techniques, you can spice up your art and keep the painting process fresh, exciting, and fun! The examples on these pages were completed using acrylic paint.

Flat Wash This thin mixture of acrylic paint has been diluted with water (use solvents to dilute oil paint). Lightly sweep overlapping, horizontal strokes across the support.

Graded Wash Add more water or solvent and less pigment as you work your way down. Graded washes are great for creating interesting backgrounds.

Drybrush Use a worn flat or fan brush loaded with thick paint, wipe it on a paper towel to remove moisture, then apply it to the surface using quick, light, irregular strokes.

Save Time—Plan Ahead!

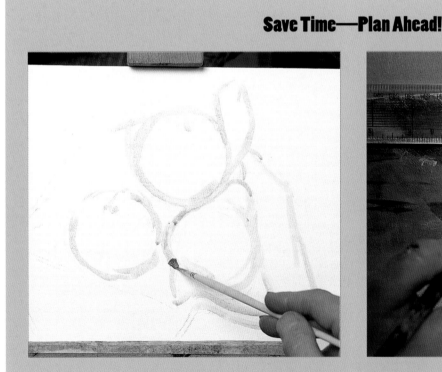

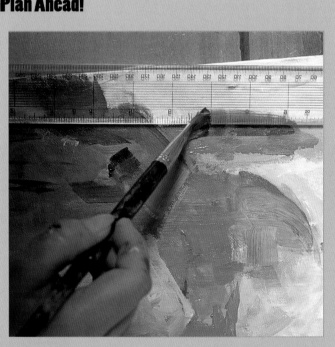

Sketching Your Subject Taking an extra moment to prepare before you paint will ensure successful results and will save you time. For example, make a sketch of your subject before you begin applying washes.

Taking Precautions Keep tools on hand that might be helpful, like a ruler, artist's triangle, or straightedge that can be used as a guide. And be sure to have paper towels and lint-free rags handy, as well as an ample supply of water or turpentine for rinsing, diluting, and cleaning up.

More Basic Techniques

Thick on Thin Stroking a thick application of paint over a thin wash, letting the undercolor peek through, produces textured color variances perfect for rough or worn surfaces.

Dry on Wet Create a heavily diluted wash of paint; then, before the paint has dried, dip a dry brush in a second color and stroke quickly over it to produce a grainy look.

Impasto Use a paintbrush or a painting knife to apply thick, varied strokes, creating ridges of paint. This technique can be used to punctuate highlights in a painting.

Scumble With a dry brush, lightly scrub semi-opaque color over dry paint, allowing the underlying colors to show through. This is excellent for conveying depth.

Stipple Take a stiff brush and hold it very straight, with the bristle-side down. Then dab on the color quickly, in short, circular motions. Stipple to create the illusion of reflections.

Scrape Using the side of a palette knife or painting knife, create grooves and indentations of various shapes and sizes in wet paint. This works well for creating rough textures.

Mask with Tape Masking tape can be placed onto and removed from dried acrylic paint without causing damage. Don't paint too thickly on the edges—you won't get a clean lift.

Lifting Out Use a moistened brush or a tissue to press down on a support and lift colors out of a wet wash. If the wash is dry, wet the desired area and lift out with a paper towel.

Glazing

Glazes are thin mixes of paint and water or acrylic medium applied over a layer of existing dry color. An important technique in acrylic painting, glazing can be used to darken or alter colors in a painting. Glazes are transparent, so the previous color shows through to create rich blends. They can be used to accent or mute the base color, add the appearance of sunlight or mist, or even alter the perceived color temperature of the painting. When you start glazing, create a mix of about 15 parts water and 1 part paint. It's better to begin with glazes that are too weak than ones that are too overpowering, as you can always add more glazes after the paint dries.

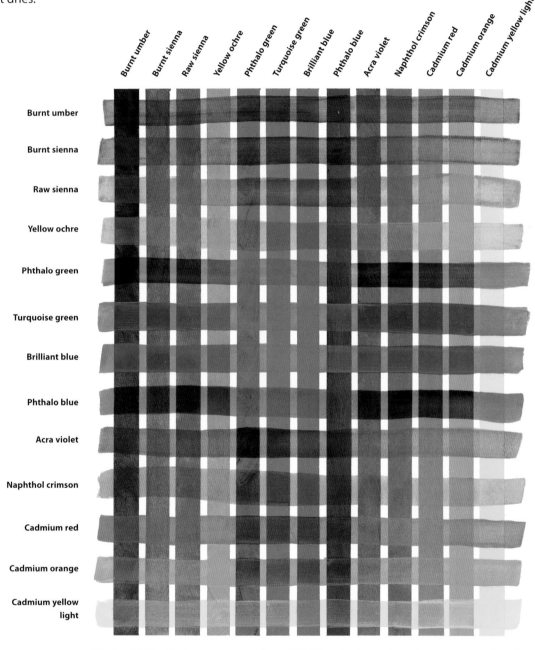

Glazing Grid In this chart, transparent glazes of 13 different colors are layered over opaque strokes of the same colors. Notice how the vertical opaque strokes are altered by the horizontal translucent strokes.

Painting Knife Knives are frequently used to mix paint, but using your knife to paint with as well as mix can add real drama to your painting. Use the flat blade to spread a thick layer of paint over the surface. Each knife stroke leaves behind thick ridges and lines where it ends, mimicking rough, complex textures like stone walls or rocky landscapes. Or you can use the edge of the blade, working quickly to create thin linear ridges that suggest and define shapes. Even the point of the knife is useful; it can scrape away paint to reveal whatever lies beneath.

Applying an Underpainting

An underpainting is a thin wash of color that is applied to the support at the beginning of the painting process. An underpainting can be used to simply tone the support with a wash of color to help maintain a desired temperature in a final painting—for example, a burnt sienna wash would establish a warm base for your painting; a blue wash would create a cool base. An underpainting can also provide a base color that will "marry with" subsequent colors to create a unified color scheme. You can also use an underpainting to create a visual color and value "map," giving you a guideline for applying future layers. An underpainting can help provide harmony and depth in your paintings. Experiment with various underpaintings to discover which colors you prefer.

Magenta

Burnt sienna

Purple

Phthalo violet

Underpainting for Temperature In the example at left, the flower has been painted over two different underpaintings: magenta (left) and light blue (right). Although the final flower is painted with identical colors on both sides of the canvas, the underpainting color greatly affects the appearance of the later layers of color. Notice that the left half of the flower appears significantly warmer in temperature, whereas the right half has a cool blue undertone.

Using Frisket

Frisket is a masking material that is used to protect specific areas of a painting from subsequent layers of color. You can use frisket on a white surface or over previously applied color that has been allowed to dry. Liquid frisket is a type of rubber cement that is applied with a brush or sponge. When applied with a brush, it can be used for saving areas of fine detail, such as the veins of a leaf or the highlight of an eye; when applied with a sponge, it can be used to create random textures and patterns. When you're done painting, simply rub off the dried frisket with your finger. Paper frisket comes in sheets or rolls; cut out the shape you want to mask and place it sticky-side-down on the area of the painting you want to protect.

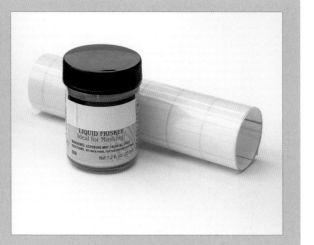

Painting Thinly and Thickly

Painting Thinly

Acrylic paint is generally described as an opaque medium, but you also can use acrylic as you would watercolor—in thin, diluted layers of color, or glazes. You can lighten the value of an acrylic wash by adding more water to the pigment, which in turn allows more of the support to show through the color. This gives the paint a luminous quality. You also can layer thin washes of acrylic paint to build up rich color. Because acrylic is waterproof when dry, you can layer new glazes over previous ones without lifting the initial pigment.

Painting Thickly

To create a rich, buttery texture like frosting on a cake, apply thick layers of paint to your support using your paintbrush or a palette knife. Use the paint straight from the tube, or consider adding a paint-thickening medium, such as gel. Called "impasto," this technique allows you to create ridges and peaks of paint with quick, short strokes from varying angles and directions, adding physical dimension and texture to your painting. Don't overwork the paint—just keep your strokes loose and fresh.

Using Impasto This technique is ideal for creating foamy water, as shown.

Diluting Acrylic Paint The transparent properties of thinned acrylic paint are perfect for depicting delicate, colorful subjects, such as the clear and reflective surfaces of glass and the fragile, soft curves of flower petals shown here. By thinning acrylic with generous amounts of water, you can achieve the airy quality of watercolor with a greater degree of control over your washes, as demonstrated in this light-filled painting of a vase of roses.

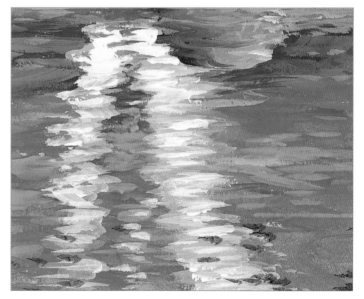

Emphasizing Highlights Punctuate the highlights in your painting (such as the white areas of rippled water shown here) by layering thick applications of paint over the highlighted areas.

Dabbing and Texturizing

Dabbing

To build up color in soft dabs, load the tip of your brush with paint and dot on color in a jabbing motion. This technique builds up layers of paint to create the illusion of depth and dimension, also adding an airy, impressionistic look to your painting. It's best to work from dark to light when using this technique, as you'll want to apply the lightest areas and highlights last. colors you prefer.

Building up Layers Layering dabs of several different shades of green and yellow gives fullness and dimension to foliage, as shown in this example.

Texturizing

Because acrylic dries quickly, this medium lends itself to a variety of physical texturizing techniques. Besides applying thick impasto applications to your support, you can mix in additives, such as painting mediums, sand, or eggshells. Or you can press bubblewrap, plastic wrap, coins, or fabric into wet paint to create interesting patterns and textures.

◄ **Building up Texture** Add interesting textures to your paintings by randomly pressing a balled-up piece of plastic wrap into the wet paint. The mottled texture that results (shown here in the beginning stages of a painting) will create visual interest wherever it shows in the finished painting.

Acrylic Gels and Pastes

Gels and pastes are the "secret" ingredients that will allow you to take your creative ideas and explorations to new heights. There are many gels, pastes, and grounds that can be used alone, together, or layered in any combination and mixed with any of the paints; therefore, the opportunity to explore countless avenues for personal expression is right at your fingertips. Finding "your voice," artistically speaking, has never been so easy and so much fun.

These materials are all made of the same ingredients: water and acrylic polymer solids. For you, this means creative freedom. You can mix, layer, and combine them in any way you wish to create endless variations and spectacular effects. The fast dry time lets you "layer up" to your heart's delight. Unlike oils, which have oppressive rules and dry times, acrylics allow you to follow your musings without fear of improper application techniques.

Gels can be thought of as colorless paint—they are made from binder but contain an added swelling agent to give them a heavier viscosity. They are offered in gloss, semi-gloss, and matte sheens and in viscosities ranging from light and (almost) pourable (like yogurt) to extra heavy (like peanut butter). Pastes are gels with solids added (marble dust, calcium carbonate, glass beads, etc.). This gives them body, which results in interesting textures and sculptural effects. Mediums are a low-viscosity polymer that you can use to thin paint for a better flow and to create glazes.

Light Molding Paste

Clear Tar Gel

High Solid Gel (Matte)

Coarse Pumice Gel

Regular Gel (Matte)

Crackle Paste

Coarse Molding Paste

Extra Heavy Gel (Gloss)

Clear Granular Gel

Fiber Paste

Coarse Pumice Gel

Fiber Paste

Molding Paste

Coarse Molding Paste

Light Molding Paste

Glass Bead Gel

Heavy Gel (Gloss)

Extra Heavy Gel (Matte)

When tinted with color, the unique qualities of the gels and pastes become more apparent. You can use all gels and pastes in the following ways:
• As a surface texture on which to paint (called a ground)
• Mixed with paint for added body and sheen (called as a medium)
• Applied on top of your painting for a covering effect

Soft Gel (Matte)

Clear Granular Gel

Clear Tar Gel

Self Leveling Clear Gel

Mineral and Modern Pigments

Pigments are what make paints colorful, and they come in a wide array of hues (reds, greens, blues, browns, etc.). Pigments also come in two classifications: mineral (inorganic) and modern (organic). Although they share some similar characteristics, their makeup and behavior are different. Mineral pigments have earthy sounding names, such as sienna, ochre, cadmium, cobalt, and ultramarine. Modern pigments have names that allude to their chemical origins, such as quinacridone, phthalo, hansa, dioxazine, and anthraquinone. Knowing their unique characteristics will help you make accurate color-mixing choices.

Mineral pigments are generally characterized by:
• high opacity (very opaque)
• low chroma (less vibrant)
• low tinting strength (do not strongly change the colors they are mixed with)

Modern pigments are generally characterized by:
• high translucency (very transparent)
• high chroma (very vibrant)
• high tinting (strongly change the colors they are mixed with)

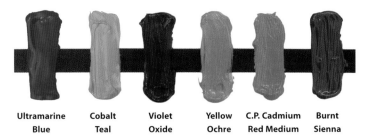

Ultramarine Blue | Cobalt Teal | Violet Oxide | Yellow Ochre | C.P. Cadmium Red Medium | Burnt Sienna

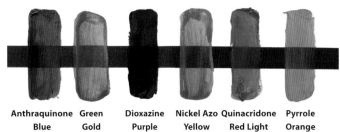

Anthraquinone Blue | Green Gold | Dioxazine Purple | Nickel Azo Yellow | Quinacridone Red Light | Pyrrole Orange

Use minerals if you want to layer one color over another without seeing the layer underneath; use moderns if you want to layer colors and allow the bottom-most colors to show through and influence the upper layers.

It is possible to achieve a wide spectrum of colors by mixing only the three primary colors: red, yellow, and blue (plus white). The color wheels below show which hues result from using mineral or modern pigments. Depending on your preferences, you can control the hues in your painting by choosing the type of pigments that suit your artistic vision.

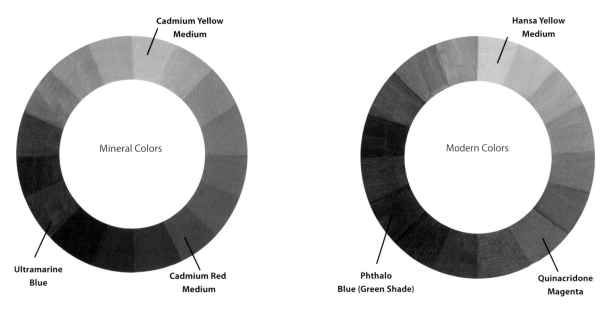

Mineral Colors — Cadmium Yellow Medium, Ultramarine Blue, Cadmium Red Medium

Modern Colors — Hansa Yellow Medium, Phthalo Blue (Green Shade), Quinacridone Magenta

Keep in Mind
• You are not limited to choosing one or the other—you can mix mineral and modern colors together to achieve greater color subtleties and nuances.
• Professional-grade artist colors always offer the highest ratio of pigment to binder in your paint. Student-grade paints have fillers and extenders that make even the mineral pigments more translucent and weaken the vibrancy of the modern hues. When it comes to paint, you get what you pay for!

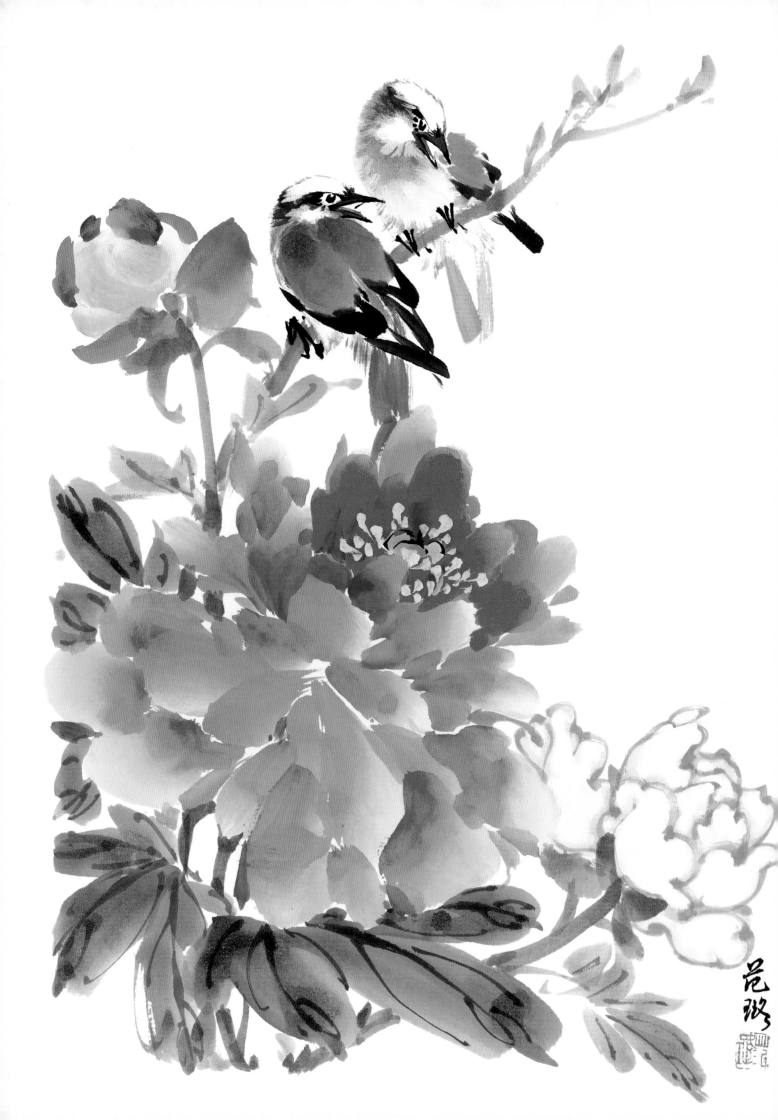

CHAPTER 6

additional mediums

Airbrushing Tools and Materials

The pros and cons of different airbrushes can be discussed at length, but it's really about what works best for you. If you can find an airbrush that can spray larger amounts of paint and deliver detailed strokes without causing hand cramps, you will be able to work comfortably and effectively. Many airbrush artists have different airbrushes for different needs.

Some variables to consider in selecting an airbrush include:
• Ergonomics - The weight displacement and comfort of the airbrush compared to the weight and shape of your hand.
• Project Scale - Whether you will need to blast a high volume of paint, create detail, or both.
• Trigger Sensitivity - How the airbrush responds to pressure on the trigger can increase or decrease your level of control.

Cleaning Tools

Teflon key rings are a must for cleaning the detailed components of an airbrush. They are usually very durable and solvent resistant, and they hold up well to many different types of liquid airbrush cleaners. You can sometimes substitute a toothbrush or other brushes with small bristles.

Air Compressors

An air compressor from a hardware store will likely be cheaper and last longer than a standard airbrush compressor from a craft store. These compressors provide pressures up to 100 psi or higher and are very portable.

Templates

Cutting your own French curves and freehand templates (A) out of plastic sheets or Mylar allows you to create whatever shape or contour the project requires. Use a stencil burner (B) to cut out the templates then refine the edges with a rotary tool (C) and sanding sponge so the paint doesn't bleed under the templates as you're spraying. Work on a metal cookie sheet or piece of glass so the stencil burner doesn't harm your tabletop surface.

Accessories

Clear contact paper (A) is useful for masking for large areas. Standard masking tape (B) allows you to quickly create tape walls that prevent overspray from traveling as well as to easily isolate or cover certain areas before or after applying paint. A utility knife (C) is useful for adding texture with subtractive highlighting, which involves removing paint from the surface.

More Airbrushing Tools and Materials

Ventilation Box

A ventilation box, positioned chest level or higher, with a fan and air filter inside can help protect your lungs from the overspray circulating in the air as you work.

Electric Eraser

An electric eraser is another tool to consider using for subtractive highlighting, which creates complexity and realism if done properly.

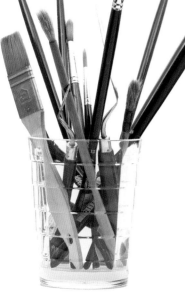

Paintbrushes

Keep an array of paintbrushes on hand to tighten and refine details, such as painting eyebrows on a portrait or rendering the crack on a piece of stone. Adding this higher level of detail ultimately leads to a good balance in your compositions.

Projector

An opaque projector greatly increases the speed of transferring an image to the painting surface. The difference in projectors typically lies in the quality or thickness of the lens. A thicker lens will allow you to get a clearer, more precise projection and will also cost you more. Many professional illustrators and fine artists use projectors to meet deadlines and keep their labor costs down. It is a very valuable tool.

Paints

The type of paint used in airbrushing varies by personal preference. Water-based airbrush acrylic paint or everyday acrylic paint enhanced with water and reducer work well. Any type of paint needs to have a thin consistency similar to skim milk in order to flow through the airbrush with continuity. Use 2 oz. bottles to mix 50% paint, 25% water and 25% reducer to achieve the desired consistency. Shake the contents before spraying.

Basic Airbrushing Techniques

Instruction will only go so far in teaching the dynamics of airbrush control. Repetition and practice, as well as patience and perseverance, are vital to understanding the technique. You will need to acclimate yourself to the weight of the airbrush, the softness of the trigger, and the peripheral view of how close you are to the surface.

Dagger and Feather Strokes

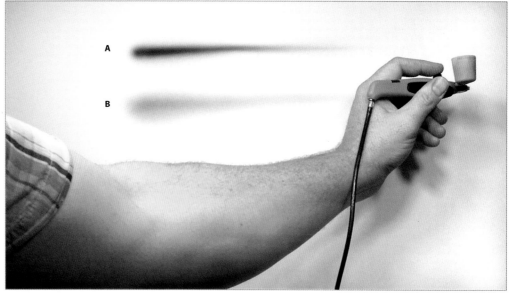

The dagger stroke (A) is the universal stroke in airbrushing. All control is learned from the mastery of this stroke.

There are three components:

1. The angle of the airbrush while spraying (normally a 10-30 degree angle when shading and tapering, and straight-on when sketching and establishing placement of the object or letter).

2. The speed in which you spray. This will vary the continuity and tapering of the stroke.

3. The amount of pressure on the trigger of the airbrush. The feather stroke (B) is a thicker, softer dagger stroke rendered with your airbrush lifted farther from the surface.

A balanced composition will contain variations of these two strokes.

Line Discrepancies

There are three predominant discrepancies to look for when troubleshooting the continuity of the paint or airbrush. These discrepancies can work together or alone to create problems. It's also important to note that, even if none of these conditions are present, you could have purchased bad paint, the surface may need different preparation, or the room temperature could be effecting the saturation.

Caterpillaring (A) is often the result of paint that has been mixed too thin. Working on a non-porous surface, such as glass or metal, can also cause this effect. You should always spray lightly and evenly on hard surfaces that tend to repel paint. A blow dryer will help keep the surface warm and assist the adhesion of the paint.

Spattering (B) happens when your paint is too thick or your pressure is starting to dissipate and getting low. An ideal operating pressure for spraying is about 50 psi and higher for 70 percent of airbrushes. More expensive airbrushes tend to function more efficiently at 40 psi; the internal components are more hypersensitive to higher pressures.

Trailers (C) are intermittent dots in your lines that indicate the accumulation of "tip dry" or paint that has formed through the atomization process of the brush. To avoid this, scrape off the tip of the airbrush about every five minutes or so using your fingernail. This will free the airflow. Trailers can also indicate that your paint needs a flow enhancer or reducer to improve the continuity of the spray.

Airbrushing Fundamentals

Remembering to work from bigger to smaller and lighter to darker will help you achieve the right balance of shading, tone, and intensity.

Bigger to Smaller
Working larger will enable you to taper your strokes with greater ease and help you fade and blend your colors. You will also have more room for spraying and be able to better understand your spatial awareness (i.e., how close you are to the surface). Working smaller allows for more detail and refinement but is also more stressful on your hands.

Lighter to Darker
Start each image by working very lightly and subtly. This entails working farther from the surface. Slowly and progressively build to darker tones by working closer to the surface. It is always easier to fix something as long as you have not sprayed too heavily. If the image gets too dark too soon, you may have to go back and make painstaking corrections.

Lines and Shadows

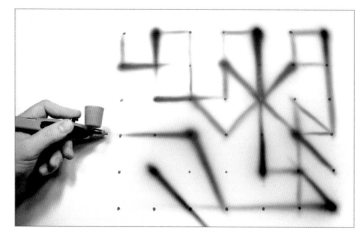

Create a pattern of synchronized dots and practice your strokes by connecting two or more of the dots in a single stroke. This will help you develop horizontal and vertical control. Notice that the angle (10-30 degrees) of the airbrush allows you to vary the tapering of the stroke. You may also use two hands if you like. Using two hands will displace the weight of your arms in a more balanced manner as you are moving up and down or side to side.

Gradient

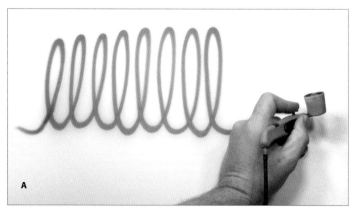

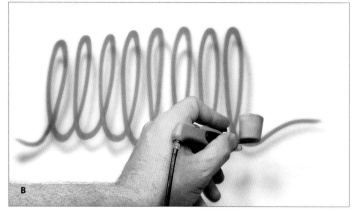

This basic exercise will help you understand the velocity of how much paint and air your airbrush is releasing. (A) First, work closely to the surface (about an inch away) and practice making these interlacing loops. You'll notice that working this close to the surface gives you a darker tone. (B) Now, lift the airbrush farther away to render a softer, lighter drop shadow. Angle the brush to the right of the original line and repeat the movement. Pay attention to the position of the airbrush to develop a better understanding of where the airbrush is vs. where the paint lands.

Block off a rectangle on a painting surface with masking tape. (A) Working about 3-5 inches from the surface, wisp the airbrush across the top of the rectangle. Continue wisping in the same direction as you work your way down, pulling back to a maximum of about 10 inches as you transition out the tone. (B) Then work about an inch or so from the surface (this is called piercing) to refine the gradient and further enhance the dark to light transition. Continue wisping in the same direction, either from left to right or right to left, to establish an even tone, also known as shading acuity.

Calligraphy Tools and Materials

Nibs

Nibs (also called "points") are writing tips that are inserted into the end of a pen holder. Nibs come in a variety of shapes and sizes, depending on the task they are designed to perform—each releases the ink differently for a unique line quality. For example, the italic nib has an angled tip for producing slanted letters, whereas the roundhand nibs feature flat tips for creating straight letters. Keep in mind that nib numbers can vary in size from brand to brand.

| #2-1/2 italic nib | Drawing nib | #4 round-hand nib | #2 round-hand nib | #1 round-hand nib |

Reservoir

A reservoir (pictured at right) is a small metal piece that slides over the nib to help control the flow of ink from the nib for smooth writing. Each brand of nib will have its own particular reservoir.

Ink

Non-waterproof black carbon ink is the best ink to use for basic lettering. Many fountain pen inks and bottled, colored inks are dye-based and will fade quickly, so it's best to use gouache for adding color.

Pen Holder

The broad end of a pen holder has four metal prongs that secure the nib. The tool should be held like a pencil, but always make sure to hold it so that the rounded surface of the nib faces upward as you stroke.

Paper

Hot-press (smooth) watercolor paper is a great choice for general lettering, whereas cold-press (medium) watercolor paper is ideal for illumination projects. You will want to have a supply of practice paper, such as layout bond or translucent paper, that you can place over guidelines or graph paper. Printmaking paper and other fine art papers also may also be used. With all fine-grade papers, keep in mind that the paper needs the right amount of sizing (a coating that makes the paper less absorbent) to work well for lettering. Too little sizing will cause the ink to spread; too much will cause the ink to sit on top of the paper.

Assembling the Calligraphy Pen

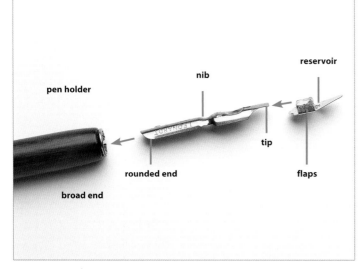

Parts of the Pen The photograph above shows the three components needed to assemble the pen: the pen holder, the nib, and the reservoir. As indicated by the arrows, the nib slides into the pen holder, and the reservoir slips over the nib.

The Pen Holder The pen holder grips the nib with four metal prongs. These prongs are made of thin metal and can be manipulated to better hold the nibs after they warp from use. Gently press the prongs toward the outer ring of the pen holder for a tighter fit.

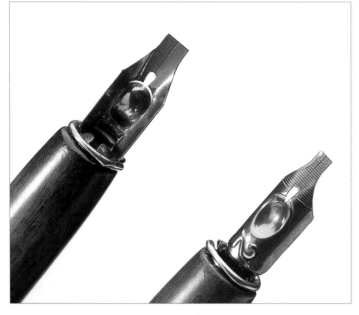

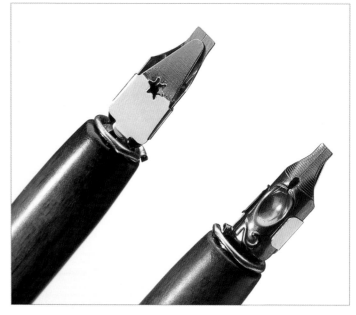

Inserting the Nib Slide the rounded end of the nib into the area between one of the metal prongs and the outer ring of the pen holder until it fits snugly and doesn't wobble. If your nib wiggles, remove it, rotate the pen holder a quarter turn, and again slide in the nib. The pen at left shows the nib from beneath, and the pen on the right shows the nib from above.

Attaching the Reservoir The gold-colored reservoir slips over the nib, cupping the underside to create a "pocket" for the ink and touching the nib near the tip to control the ink flow (left). The two flaps of this piece slide over the sides of the nib, as shown on the right. (Note that the drawing nib comes with an attached reservoir.)

Left-handed scribes can give a roundhand nib an opposite angle by grinding the tip on a sharpening stone. Specially made left oblique nibs are also available through mail-order and online art supply dealers.

Setting up a Calligraphy Work Area

Arranging Materials

Right-handed scribes using a dip pen should place everything on the right; however, when filling a pen with a brush, your palette or ink should be on the left. Left-handed scribes should reverse the position of the materials.

Right-handed Scribes

Left-handed Scribes

Developing Good Habits

To maintain your comfort level, take frequent breaks to relax your hands, back, and eyes. As you are lettering, move the paper from right to left to keep your working hand centered in front of your eyes. Clean your pen by dipping just the tip of the nib in water and wiping it dry, even if you're just stopping for a few minutes.

Preparing the Board Surface

Tape a few sheets of blotter paper, newsprint, or paper towels to the board to form a cushion under the paper. This gives the pen some "spring" and will help you make better letters. You also can work on top of a pad of paper for extra cushion. To protect the paper, place a guard sheet under your lettering hand, or wear a white glove that has the thumb and first two fingers cut off. This protects the paper from oils in the skin, which resist ink.

Positioning the Work Surface

A sloping board gives you a straight-on view of your work, reducing eye, neck, and shoulder strain. The work surface affects the flow of ink—on a slant, the ink flows onto the paper more slowly and controllably. To prevent drips during illumination, you will need to work on a relatively flat surface. Practice lettering at different angles.

Getting Started in Calligraphy

Dip pens require a little preparation and maintenance, but when properly handled, they are long-lasting tools. Before you jump into writing, you'll need to learn how to assemble, load, manipulate, and clean a dip pen. Have a stack of scrap paper handy, and take time to become familiar with the unique character of the marks made by each nib.

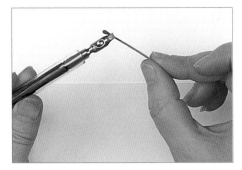

Preparing New Pen Nibs New nibs are covered with a light coating of oil or lacquer and need preparation to make the ink or paint flow properly. Wash new nibs gently with soapy water, or pass the tip of the nib through a flame for a few seconds, as shown; then plunge it into cold water.

Adjusting the Reservoir After slipping the reservoir onto the nib, adjust it (using fingers or pliers) so that it's about 1/16" away from the tip (too close interferes with writing; too far away hinders the ink flow). If it's too tight, you'll see light through the slit while holding it up to a light source.

Understanding Pen Angle The angle of the flat end of the nib to a horizontal line is known as the "pen angle." It determines the thickness of the line as well as the slant of stroke ends and serifs (small strokes at the end of letters). For most lettering, you'll use an angle of 30 to 45 degrees.

Loading the Pen It is best to use a brush or dropper to load the nib; if you dip your nib into the ink, your strokes may start out as ink blobs. Regardless of how you load your pen, it's always "a good idea to test your first strokes on scrap paper.

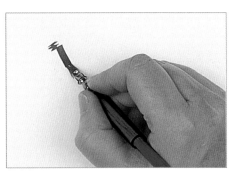

Making Even Strokes First get the ink flowing by stroking the pen from side to side, making its thinnest line, or rocking it from side to side. Keep your eye on the speed and direction of the pen as you move it. Apply even pressure across the tip to give the stroke crisp edges on both sides.

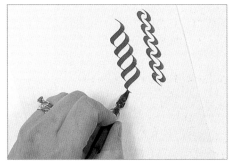

Techniques for Left-Handed Scribes To achieve the correct pen angle, you can either move the paper to the left and keep your hand below the writing line or rotate the paper 90 degrees and write from top to bottom. (You'll smear the ink if you write with your hand above the writing line.)

Understanding the Broad Pen

Practice Basic Shapes Start by making simple marks as shown above, and keep the pen angle constant to create a sense of rhythm. Pull your strokes down or toward you; it is more difficult to push your strokes, and doing so may cause the ink to spray from the nib. Practice joining curved strokes at the thinnest part of the letter, placing your pen into the wet ink of the previous stroke to complete the shape. This is easiest when your pen angle is consistent.

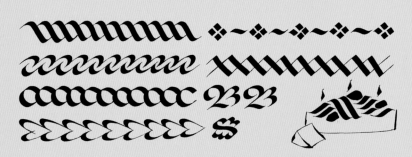

Draw Decorative Marks Medieval scribes often used the same pen for lettering as they used to decorate the line endings and margins of their texts. The broad pen can be used like any other drawing tool; practice drawing a variety of shapes to learn more about the pen's unique qualities. For instance, turn the paper to create the row of heart-shaped marks.

Calligraphy Basics

This diagram will familiarize you with the basic calligraphy terms. As you can see below, the various stroke curves and extensions of calligraphic lettering all have specific names—refer to this page when learning how to form each letter. Below you'll also see the five basic guidelines (ascender line, descender line, waist line, base line, and cap line), which will help you place your strokes.

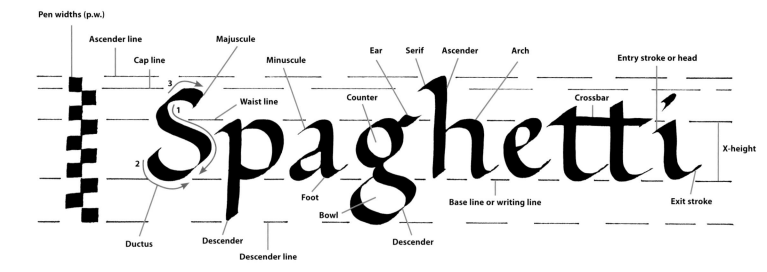

Forming the Letters

The term *ductus* refers to the direction and sequence of the strokes, which are indicated throughout with red arrows and numbers around the letter examples above. Broad pen letters are formed with a series of separate strokes, so it's important to follow the recommended ductus while learning; however, with experience, you'll develop your own shortcuts to forming the letters.

Learning Proper Terminology

The terms "uppercase" and "lowercase" come from the era of hand-set type, when individual metal letters were stored in shallow cases; therefore, these terms should not be used in calligraphy. It's better to use the terms "majuscules" (for uppercase letters) and "minuscules" (for lowercase letters). Also avoid using the term "font," which generally refers to computer-generated letters; when referring to different hand-lettered alphabets, use the term "style" or "hand."

Do not press down on your paint nib too hard because it will drag on the surface of the paper and may stick in one spot, causing a blot.

Preparing Calligraphy Paper

No matter what your skill level, you'll usually need guidelines present when doing calligraphy. Without these helpful marks, your writing can lose the rhythm, consistency, and visual alignment that make calligraphy so pleasing to the eye. Follow the steps below to prepare your writing surface with all the necessary guidelines. Remember that you can easily erase light pencil lines when finished, removing any trace of them from your completed work.

Make a Paper Ruler On a small piece of paper, mark a series of short pen-width lines, as shown. Turn the pen 90 degrees and begin at the base line, forming a set of stacked squares. Using the pen width as the unit of measurement will keep your letter height in proportion with the line thickness. Each practice alphabet has a designated pen width (p.w.) height, indicating the number of squares needed.

Mark the Guidelines Place the paper ruler along the edge of your paper and use it to position horizontal guidelines across the paper. A T-square is easier to use than a regular ruler, as you can draw guidelines that are perfectly perpendicular to the vertical edge of your paper. Mark the base line, waist line, ascender line, descender line, and cap line (if working with majuscules).

Improve Your Lettering with Practice

- Warm up your arm and hand first to gain a sense of control, and remember to take frequent breaks.

- Begin each exercise with the largest nib; this makes it easier to see the contrast between thick and thin strokes created by the broad pen.

- Use smooth, lightweight, translucent paper with a sheet of guidelines placed beneath it for practice.

- Choose the lettering style you like best to practice first. The examples in this book are some of the easiest to learn and require the least pen manipulation or twisting of the pen holder.

- Practice lettering and establishing a rhythm by writing an **o** or **n** between each letter. As soon as you feel comfortable forming letters, start writing whole words.

- Directly trace the letter shapes using a scan or photocopy to practice; this is helpful for beginners and may help you better understand pen angle. On each style page, you'll discover at what percentage the letters have been re-produced in this book. Simply enlarge the letters to 100% on a photocopier for tracing purposes. (For example, if the letters are at 75%, divide 100 by 75. When you get the answer—1.33—convert this to a percentage (133%) and copy your letters at this size.)

- Calligraphy, like dance or yoga, requires practice to achieve grace and flow. Relax and enjoy a peaceful time as you train your hand to shape each letter.

Basic Calligraphy Form: Skeleton Miniscules

Mastering the skeleton hand gives you the basic skills for learning all the other hands. This hand features the basic underlying structure (or skeleton) of the letterforms. Practicing these letters will train your hand to remain steady while drawing straight and curved lines. These letters were created with the drawing nib, which makes a thin stroke, but you can use a fine-line marker or a pencil for practice if you wish. As you re-create the letters of this hand, as well as any other hand, remember that part of the charm and appeal of hand lettering is the imperfections. Hand-lettered alphabets throughout won't align exactly on the guidelines. (This hand is shown at 85% of its actual size.)

Minuscules

Learning the subtleties of the letter shapes will make the difference between creating plain-looking letters and beautiful ones. Notice that the **o** fills the entire width of a square (equal to 4 grid boxes by 4 grid boxes). Other round letters are about 7/8 the width of that square, and most of the other minuscules (except for the **i**) are 3/4 the width of the square. Proportion and alignment, as well as consistency, all play a part in giving your writing a clean look and producing characters that are easy to read. As you can see, certain letters share common shapes. Practice the different styles using these letter families. By practicing the letters in these groups, you will learn the forms faster.

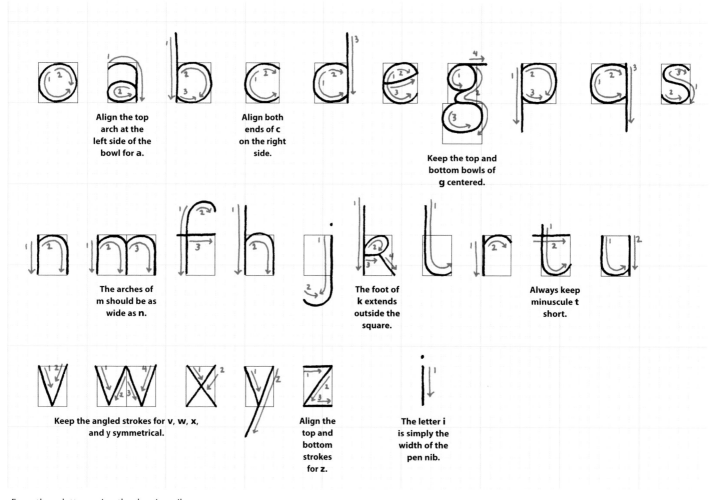

Align the top arch at the left side of the bowl for **a**.

Align both ends of **c** on the right side.

Keep the top and bottom bowls of **g** centered.

The arches of **m** should be as wide as **n**.

The foot of **k** extends outside the square.

Always keep minuscule **t** short.

Keep the angled strokes for **v, w, x,** and **y** symmetrical.

Align the top and bottom strokes for **z**.

The letter **i** is simply the width of the pen nib.

Form these letters using the drawing nib.
This hand is shown at 85% of its actual size.

Basic Calligraphy Form: Skeleton Majuscules

Majuscules

When drawing majuscules, also called "Romans" by calligraphers, understanding the correct proportions will allow you to consistently form handsome-looking letters. Note that the shape of the **o**, which is the "mother" of every alphabet, will determine the shapes of almost all the other letters.

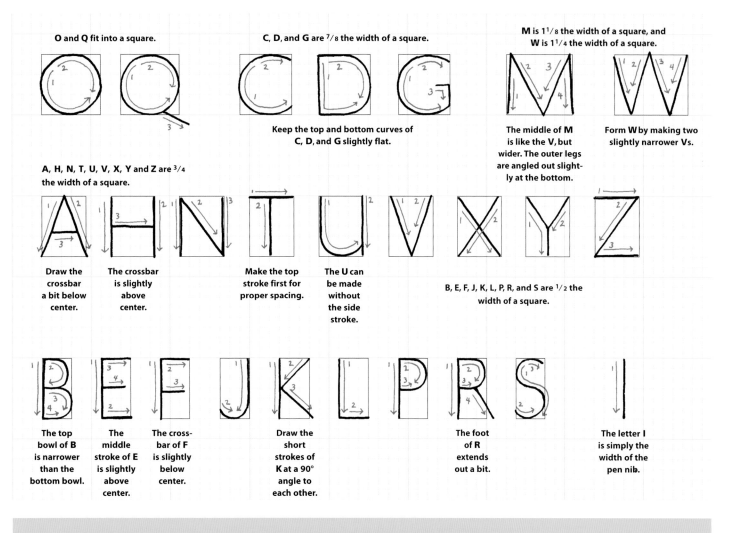

O and Q fit into a square.

C, D, and G are 7/8 the width of a square.

Keep the top and bottom curves of C, D, and G slightly flat.

M is 1 1/8 the width of a square, and W is 1 1/4 the width of a square.

The middle of **M** is like the **V**, but wider. The outer legs are angled out slightly at the bottom.

Form **W** by making two slightly narrower **V**s.

A, H, N, T, U, V, X, Y and Z are 3/4 the width of a square.

Draw the crossbar a bit below center.

The crossbar is slightly above center.

Make the top stroke first for proper spacing.

The **U** can be made without the side stroke.

B, E, F, J, K, L, P, R, and S are 1/2 the width of a square.

The top bowl of **B** is narrower than the bottom bowl.

The middle stroke of **E** is slightly above center.

The cross-bar of **F** is slightly below center.

Draw the short strokes of **K** at a 90° angle to each other.

The foot of **R** extends out a bit.

The letter **I** is simply the width of the pen nib.

Tips

- Remember to experiment! Always test new nibs and papers before starting a final work to see how they respond to the paints or ink.

- You may need to adjust the thickness of the watercolor or gouache according to the angle of your work surface or lay your paper on a less oblique angle to work.

- Keep your work area clean, and check your fingertips when handling finished work. I keep a damp paper towel nearby to wipe off my fingers before touching the paper.

- Use a constant speed as you form your letters; this gives your work a rhythm and helps you make the letters more consistent.

Chinese Brush Tools and Materials

In Chinese Brush painting, the paintbrush, paper, ink, and ink stone are called "The Four Treasures" of an artist's studio. Below is a list of these and other necessities you'll need to get started.

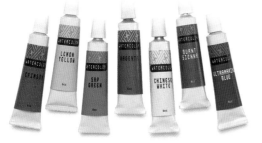

Paints

Chinese pigments are made from semi-precious stones, minerals, and/or plants, and they are available in both tube and cake colors. Most Chinese Brush artists mix them with a bit of water; the less water, the more intense the color.

Ink Stick and Stone

To use an ink stick and stone, put one teaspoon of fresh water in the well of the stone. Quickly grind the ink stick in a circular motion for about three minutes until the water becomes thick and dark black. Before each use, make sure the stone is clear of dry ink. Always use fresh water each time you paint, and always grind the same end of the ink stick.

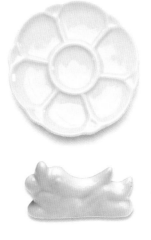

Brushes

Chinese brushes are similar to watercolor brushes, but they have finer tips. Wolf-hair brushes are the most versatile of the Chinese brushes. They have stiff, highly resilient bristles that are used for painting leaves and branches, especially those of orchids and bamboo. Goat-hair brushes are soft, pliant, nonresilient brushes that are used for depicting soft things, such as animal fur, petals, and large areas of color. New brushes have sizing in the bristles: a substance that keeps the bristles' shape. Soak your brushes in water to remove the sizing before use.

Palette

Use a ceramic mixing palette so you can mix multiple washes at once.

Brush Rest

Place the tips of your brushes on a ceramic brush rest to keep the bristles protected between uses. Never let the bristles stand in water.

Other Materials

Watercolor paper is great for Chinese brush painting because it's versatile and easy to paint on; the paper absorbs the paint just enough without allowing the colors to bleed. As you progress, you may want to buy some rice paper, the primary painting surface of Chinese brush painters for more than 2,000 years.

Paper towels come in handy for drying and blotting brushes and for testing colors. You may wish to use a paperweight to hold your paper still while you paint and to prevent it from curling. Also, it's a good idea to keep two jars of clean water nearby: one for rinsing your brushes, and one for adding water to your palette.

Chinese Brush Fundamentals

Handling the Brush

To create the expressive brushstrokes used in Chinese painting, it's important to be comfortable and to hold the brush correctly. Sit up straight and lay the paper on your table or work surface. Place a piece of white felt or newspaper under the paper to keep it from moving and to protect your table. Then practice making the various strokes shown below, holding the brush in the vertical and slanted positions, as needed. These positions may seem awkward at first, but once you get used to them, you will be able to form the strokes correctly.

Each stroke requires one fluid movement—press down, stroke, and lift. All of your brushstrokes should move in a definite direction; you should always be either pulling or pushing your brush. Use your second finger to pull and your third finger to push. Hold the brush gently, letting it lightly caress the paper. Pressing too hard emits too much ink and makes it difficult to control. Practice applying only the slightest pressure to affect the shape and width of your brushstrokes.

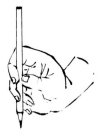

Vertical Hold Hold the brush perpendicularly to the paper. Grasp the handle just below center, placing it be-tween your thumb and index finger and resting the lower part on the nail of your ring finger. Rest your middle finger on the handle just below your index finger. Support your third finger with your pinkie, and brace the handle with your thumb.

Slanted Hold Hold the brush so it's almost parallel to the paper and use your thumb and fingers to control the movement of the brush, as shown. The width of the stroke is determined by the angle of and the pressure on the brush. The shape of the stroke is determined by the movement of the brush: press and lift, push and pull, turn and twist, or dash and sweep.

Slanted Strokes Hold the brush almost parallel to the paper and, in one fluid movement, press down, stroke, and lift, using your thumb and fingers to control the movement of the brush. Use slanted strokes to paint large areas, broad shapes, and washes.

Vertical Strokes Hold your brush perpendicularly to the paper. Stroke from top to bottom, thickening your line by gradually pressing the brush down on the paper. Use this stroke for outlines, branches, clothing, and other detailed lines.

Color Mixing There are two basic methods for mixing colors on your brush: dipping and tipping. For dipping, fully load your brush with the first color; then dip the bristles halfway into the second color. For tipping, touch only the tip of the bristles into the second color. Each time a color is applied, rotate the brush on the side of the dish to blend. (Note: You can lighten any mixture by dipping your brush in clean water.)

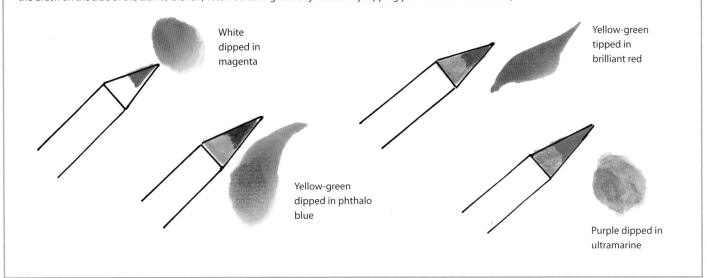

White dipped in magenta

Yellow-green tipped in brilliant red

Yellow-green dipped in phthalo blue

Purple dipped in ultramarine

Chinese Brush Basic Strokes

Chinese painting strokes were developed from traditional calligraphic strokes thousands of years ago. The relationship between the two art forms is still apparent today, as shown in the examples on this page. There are two basic strokes based on calligraphy: the water-drop stroke, which is made by holding the brush in the slanted position, and the bone stroke, which is made by holding the brush vertically. Below are eight different strokes that incorporate either the water-drop stroke, the bone stroke, or both. Practice these strokes over and over on newsprint until you master them.

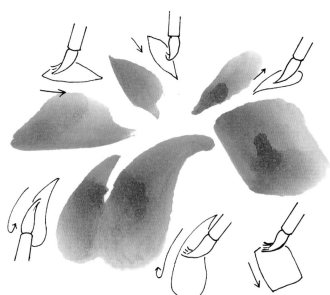

▶ **Leaf and Petal Strokes** Some of the same basic strokes shown below are also used to paint petals and leaves. Practice these strokes with a wolf-hair brush.

▶ **Basic Strokes** Try to keep your wrist and hand flexible as you practice. Follow the arrows for making each brushstroke, working either from top to bottom or bottom to top. For thicker lines, press down harder on the brush; for thinner lines, use a lighter touch. Once you can accomplish these strokes with ease, try painting some of the Chinese symbols shown below. Notice that each symbol is simply a combination of basic strokes.

Horizontal bone stroke

Vertical bone stroke

Combined vertical and horizontal bone stroke

Hook stroke—vertical line with a water-drop stroke at the end

Short water-drop stroke— top to bottom

Long water-drop stroke— top to bottom

Reverse water-drop stroke—thicker at top

Water-drop stroke with a thick end

Yellow 黄

Thousand 千

新
禧

恭
賀

福 Good fortune

春 Spring

Happy New Year

Getting Started in Chinese Brush

Bamboo

Bamboo is one of four plants in the traditional study of Chinese brush painting techniques, along with the orchid, plum blossom, and chrysanthemum. These four plants—called "The Four Gentlemen"—represent the noble virtues of Chinese life, which include strength, beauty, honor, and longevity. The straight, hollow bamboo stalks symbolize the Buddhist and Taoist ideals of an emptied heart and mind, cleansed of earthly desires and reflecting a modest personality.

Monochromatic Painting

A painting done in only one color is called "monochromatic." In a monochromatic ink painting, black ink is separated into seven distinct shades, from deep black to white, as shown in this simple bamboo demonstration. Zhong Ren, a Buddhist monk still known for his Zen philosophy of "simplicity," created this medium during the North Song dynasty (A.D. 960–1127) to express his love of nature in a simple form.

▶ **Composition** Keep your bamboo paintings simple and balanced. Paint three sets of leaves close together on one deer's horn-shaped branch (see below), angling each set in a different direction.

▲ **Value Scale** This chart shows seven distinct shades, or values, of black. You can create these values by adding varying amounts of water to black ink; the more water, the lighter the value.

▶ **Stalk** For the base of the stalk (below), hold a wolf-hair brush upright, press the bristles down, and stroke from the bottom to the top. Each section of the stalk should be straight and of even width, with equal distance between each knot. As you stroke upward over the stalk, hesitate at each knot without lifting your brush off the paper.

Deer's Horn

▶ **Branches** Using light gray ink and bone strokes, paint one branch growing out of each knot. Hold a wolf-hair brush upright, start at the bottom, and stroke upward. Then for the deer's horn shape, paint three slightly curved bone strokes, placing the middle line lower than the other two lines. For the joint, load a wolf-hair brush with dark black ink, remove the excess liquid, and paint dark knots along the stalk, as shown at right.

Joint

▶ **Leaves** Load a wolf-hair brush with a light value of ink, and dip the tip in dark black ink. Press down and, using your middle finger, gradually pull up as you stroke downward. Paint the two larger leaves so they cross at the top. Add two side leaves and a short stem to the set.

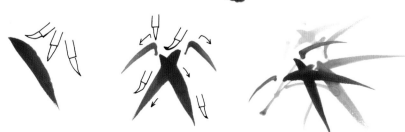

100 things every artist

CHAPTER 7

color and light

Introduction to Color

A fundamental knowledge of color can assist you in clearly expressing yourself in your art. Color helps communicate feelings, mood, time of day, seasons, and emotions. Knowing how colors work, and how they work together, is key to refining your ability to communicate using color.

The Color Wheel

A color wheel is a visual representation of colors arranged according to their chromatic relationship. The basic color wheel consists of 12 colors that can be broken down into three different groups: primary colors, secondary colors, and tertiary colors.

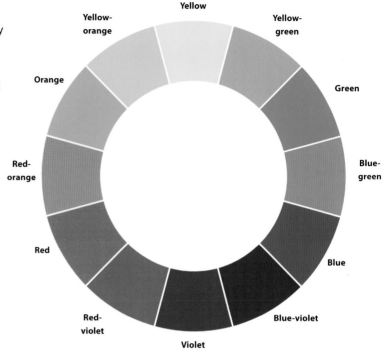

Creating Wheel References

One of the easiest things to create is a 12-color color wheel with just the three primaries: red, yellow, and blue. All colors are derived from these three. Beginners should mix a color wheel with both the primaries and secondaries. This can help you understand how to create additional colors, see how colors interact, indicate if you have too many colors (do you really need five reds?), and see your palette of colors in spectrum order.

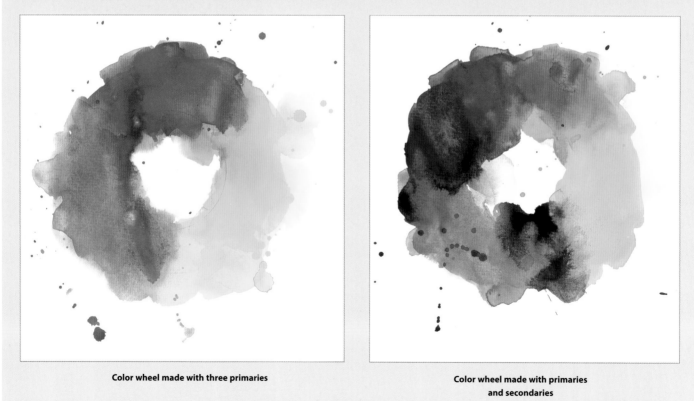

Color wheel made with three primaries

Color wheel made with primaries and secondaries

The Basics of Color

Primary Colors

The primary colors are red, yellow, and blue. These colors cannot be created by mixing any other colors, but in theory, all other colors can be mixed from them.

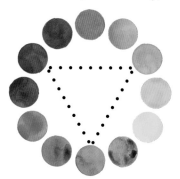

Secondary Colors

Secondary colors are created by mixing any two primary colors; they are found in between the primary colors on the color wheel. Orange, green, and purple are secondary colors.

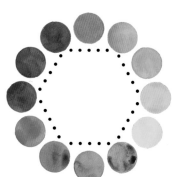

Tertiary Colors

If you mix a primary color with its adjacent secondary color, you get a tertiary color. These colors fill in the gaps and finish the color wheel. Tertiary colors are red-orange, red-violet, yellow-orange, yellow-green, blue-green, and blue-violet.

Color Schemes

Choosing and applying a color scheme (or a selection of related colors) in your painting can help you achieve unity, harmony, or dynamic contrasts. This page showcases a variety of common color combinations. Explore these different schemes to familiarize yourself with the nature of color relationships and to practice mixing colors.

Complementary Color Schemes Complementary colors are opposite each other on the color wheel. Red and green (shown above), orange and blue, and yellow and purple are examples of complementary colors. When placed adjacent to each other in a painting, complements make each other appear brighter. When mixed, they have the opposite effect, neutralizing (or graying) each other.

Triadic Color Scheme This scheme consists of three colors that form an equilateral triangle on the color wheel. An example of this would be blue-violet, red-orange, and yellow-green (shown above).

Tetradic Color Schemes Four colors that form a square or a rectangle on the color wheel create a tetradic color scheme. This color scheme includes two pairs of complementary colors, such as orange and blue and yellow-orange and blue-violet (shown above). This is also known as a "double-complementary" color scheme.

Analogous Color Schemes Analogous colors are adjacent (or close) to each other on the color wheel. Analogous color schemes are good for creating unity within a painting because the colors are already related. You can do a tight analogous scheme (a very small range of colors) or a loose analogous scheme (a larger range of related colors). Examples of tight analogous color schemes would be red, red-orange, and orange; or blue-violet, blue, and blue-green (shown at left). A loose analogous scheme would be blue, violet, and red.

Split-Complementary Color Schemes This scheme includes a main color and a color on each side of its complementary color. An example of this (shown at left) would be red, yellow-green, and blue-green.

Color Temperature

Cool Warm

Divide your color wheel in half by drawing a line from a point between red and red-violet to a point between yellow-green and green. You have now identified the warm colors (reds, oranges, and yellows) and the cool colors (greens, blues, and purples). Granted, red-violet is a bit warm and yellow-green is a bit cool, but the line needs to be drawn somewhere, and you'll get the general idea from this. In a painting, warm colors tend to advance and appear more active, whereas cool colors recede and provide a sense of calm. Remember these important points about color temperature as you plan your painting.

Mood and Temperature

We are all affected by color, regardless of whether we realize it. Studies show that color schemes make us feel certain ways. Warm colors, such as red, orange, yellow, and light green, are exciting and energetic. Cool colors, such as dark green, blue, and purple, are calming and soothing. Use these colors schemes as tools to express the mood of the painting. In fact, you'll find that you don't even need a subject in your painting to communicate a particular feeling; the abstract works below demonstrate how color is powerful enough to stand on its own.

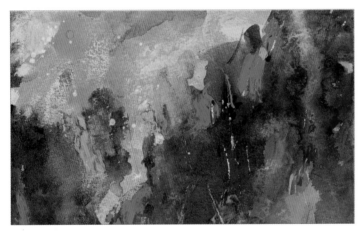

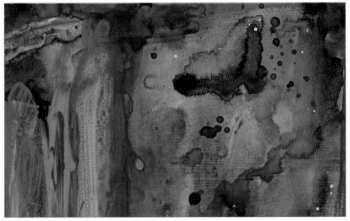

Warm Palette What is this painting of? Who knows! It doesn't matter. The point here is to express a mood or a feeling. Here the mood is hot, vibrant passion. Energetic reds and oranges contrast the cool accents of blue and purple.

Cool Palette A much different feeling is expressed in this painting. It is one of calm and gentle inward thought. The red-orange accents create an exciting counterpoint to the overall palette of cool greens and blues.

Suggesting Mood with Strokes

Color isn't the only thing that affects mood. All parts of the painting contribute to the mood of the piece, including the brushstrokes and line work. Keep these points in mind as you aim for a specific feeling in your paintings.

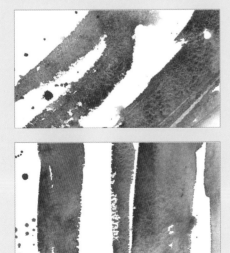

Upward Strokes (heavier at the base and tapering as they move up) suggest a positive feeling.

Downward Strokes (heavier at the top and tapering as they move down) suggest a more somber tone.

Vertical Strokes communicate force, energy, and drama.

Horizontal Strokes denote peace and tranquility.

Conveying Mood with Color

In addition to warm and cool palettes, bright and dark palettes also work well for conveying a mood. A bright palette consists of light, pure colors with plenty of white paper showing through. This gives the effect of clean, positive, uplifting energy. Darker, saturated colors covering most of the paper suggest a more serious tone—a mood of quiet somberness and peace.

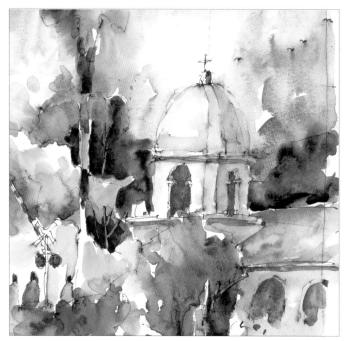

Bright Palette The pure, warm colors with plenty of white paper showing through expresses the cheer of this light-hearted scene. Complementary colors (e.g., red against green or yellow against purple) also help enliven the story.

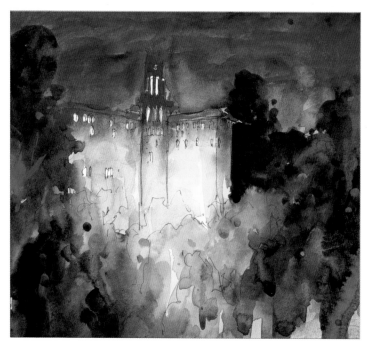

Dark Palette The darker colors in the cool range communicate a heavier mood. Here I used an analogous color scheme of cool, darker colors to indicate the quiet end of the day and the approaching night.

A painting should be primarily one temperature—either warm or cool. There should be a clear, simple message in each painting with a minimum of variables. Also, you don't want to confuse the viewer with uncertainty. However, warm accents in a cool painting (and vice versa) are certainly acceptable and encouraged. Remember, you want your statement to be exciting but clear.

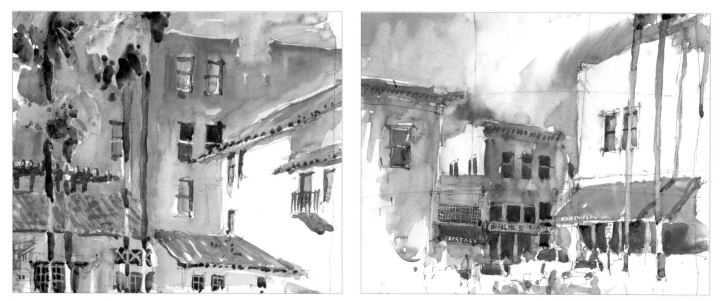

Accenting Warm and Cool Palettes These two examples feature warm and cool colors almost exclusively. The warm painting (left) suggests a hot summer day with energy in the air, and the cool painting (right) recedes into quiet and suggests a winter afternoon. Notice that in each case, complementary accents emphasize the color theme with contrast.

Color Properties

The properties of color are hue, value, and intensity. When you look at a color, you will see all three properties. Hue is the name of the color, such as red, yellow, or blue. Value refers to how light or dark a color is. Intensity is the color's brightness or dullness.

Hue

Hue refers to the color name. Here are some examples of blue hues.

Phthalo blue: a greenish blue **Cobalt turquoise light:** **Cerulean blue: a bright,** **Ultramarine blue: a cool,** **Cobalt blue: a pure blue**
a bright, greenish blue **grayish blue** **reddish blue**

Value

Value refers to the lightness or darkness of a color (or of black). Variations of color values are an important tool for creating the illusion of form and depth in your paintings. Colors have their own inherent value; squint at a color wheel and you'll see light colors, such as yellow, and dark colors, such as purple. In addition, each color has its own range of values. With watercolor, add water to lighten the value (creating a tint of the color), or add black to darken the value (creating a shade of the color).

Purple **Yellow** **Red** **Green**

Purple (grayscale) **Yellow (grayscale)** **Red (grayscale)** **Green (grayscale)**

Assessing the Value of Color Above are colors from the color wheel (top row) and how they appear in grayscale (bottom row). Viewing them in this manner reveals the true value of each color without any visual distractions. As you can see, purple is very dark, yellow is very light, and red and green are similar medium values.

Creating Value Scales Get to know the range of lights your paint colors can produce by creating a few value scales. Working your way from left to right, start with a very strong wash of your color and add more water for successively lighter values.

Intensity

Intensity refers to the purity (or saturation) of the color. Colors right out of the tube (or as they appear on the color wheel) are at full intensity. To change the intensity of watercolor paint, you can dull the color (or gray it) by adding its complement, gray, black, white, or water. Although adding black or water changes the value of the color, it also neutralizes it, dulling it and making it less intense.

Ultramarine blue right out of **Ultramarine blue dulled** **Ultramarine blue dulled with**
the tube at full intensity **with water** **burnt umber**

Color and Value

For most paintings to be successful, there should be a good value pattern across the painting, which means a clear and definite arrangement of dark, middle, and light values. This will create an effective design, which is pleasing to the eye. It also helps communicate the point of your painting in a clear and uncluttered manner. Keep in mind that these values should not be equal in a painting but rather predominantly light or dark. Equal amounts of light and dark result in a static image that lacks movement, drama, and—most important—interest.

Predominantly light painting

Predominantly dark painting

A good exercise is to make a black-and-white print of your painting. Does it read well? Can you see a separation of elements and objects without having to rely on the colors? If so, good job—your values are working for you. Too often we rely on the colors to get the point across, and we are disappointed when it doesn't happen.

To demonstrate the importance of value, the same painted scene appears three times (see below). The painting at the far left uses the appropriate colors and values. The middle painting uses the correct colors, but its values are similar to one another. The painting at the right uses the correct values, but all the wrong colors. Which of these makes a better painting—the image at center or the image at right? (Hint: The one with the correct values, at right).

Correct colors, correct values

Correct colors, incorrect values

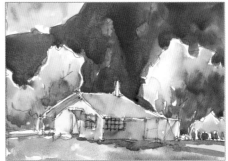

Incorrect colors, correct values

Complementary Colors

When placed next to each other, complementary colors create lively, dramatic contrasts that can add interest and excitement to a painting. In contrast, you can also mix in a little of a color's complement to dull the color. For example, mute a bright red by adding a little of its complementary color, green.

▶ **Pairing Complements** When complementary colors appear together in nature, they create striking scenes—for example, red berries among green leaves, an orange sun against a blue sky, or the yellow center of a purple iris.

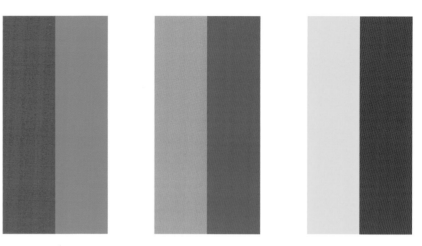

Contrasting Colors

When light values are placed next to dark values, the effect can be strong and dramatic. Pairing contrasting complementary colors in a painting creates a visual vibration that excites the eye.

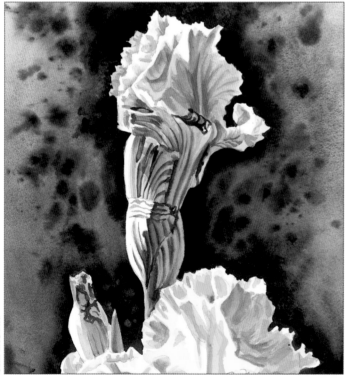

GERI MEDWAY

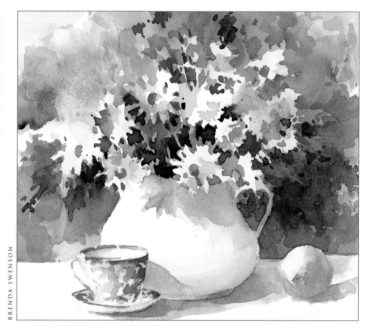

BRENDA SWENSON

Making elements "POP" In this floral painting, notice the way placing a yellow iris against a background of greens, blues, and purples gives the colors a jewel-like quality and adds vibrancy. The contrast between the complementary colors, yellow and purple (paired with harmonious blue and green), makes the irises "zoom" forward.

Lighting the Subject Another benefit to working indoors is lighting control. Artificial lighting lets you work at night or on rainy days. And with artificial light, you can manipulate the direction and strength of the light source for interesting shadows. You may want to use natural light—such as light from a window—when indoors; but natural light can interfere with artificial light, so it's best to use only one.

Color Schemes in Paintings

Color schemes are combinations of colors that create an appealing visual dynamic. There are many types of color schemes, several of which are shown below. Some schemes create contrast and excitement; others create harmony and peace. Keep in mind that each scheme affects the subject of a painting differently, so it's important to assess your goals and select a color scheme before you begin painting. Also, note that color schemes are a general way of categorizing the dominant colors used in a painting; not every single color used in a painting has to be straight from the selected color scheme.

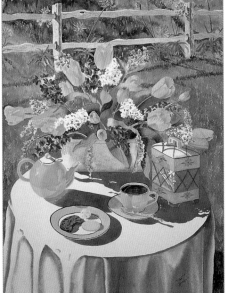

JOAN HANSEN

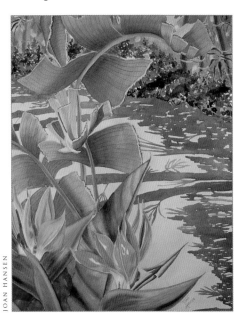

JOAN HANSEN

GERI MEDWAY

Complementary Color Scheme The dominant colors in this painting are yellow-orange and blue-violet, which lie opposite each other on the color wheel. The artist has placed these two colors adjacent to one another throughout the still life, which makes the complements appear especially vibrant.

Triadic Color Scheme This scheme combines three colors that are evenly spaced apart on the color wheel. Using all three of these colors in equal weight can overwhelm the viewer, so it's best to allow one color to be more prominent (such as the green in this painting).

Analogous Color Scheme This harmonious scheme combines colors that are adjacent to one another on the color wheel, so they are all similar in hue. In this particular instance, the artist has muted (or grayed) all of the colors to communicate the quiet and solitude of diffused, early morning light.

JOAN HANSEN

ROSE EDIN

◄ **Split-Complementary Color Scheme** This scheme combines a color (in this case, blue) with two colors adjacent to its complement (yellow-orange and red-orange). The scheme retains a hint of the vibrant interplay of a complementary scheme but includes more variety in hue.

Tetradic Color Scheme This color scheme involves two pairs of complements (such as red-orange/green and yellow-orange/blue-violet), creating a square or rectangle within the color wheel. The complements vibrate against one another and produce a colorful scene full of life. Notice how this dynamic makes the flowers seem to "pop" from the background.

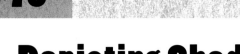

Depicting Shadows and Light

Once you've become comfortable with mixing colors and composing a scene, you're ready for the next step: making two-dimensional objects appear three-dimensional. Flat objects can appear to have depth and dimension when they possess a range of light, dark, and medium values—also referred to as "highlights," "shadows," and "local color" (the actual color of the object itself). Use contrasts in color values to define the forms of your subjects, as well as to create visual interest in your paintings.

Form and Cast Shadows

There are two main categories of shadows that play roles in giving depth and interest to objects. Form shadows (the shadows on the surface of an object) are responsible for giving an object a sense of depth and dimension, whereas cast shadows (the shadows the object throws onto other surfaces) can anchor or ground the object in space.

Form shadow

Cast shadow

▶ **Form vs. Cast Shadows** You can distinguish form and cast shadows by studying their differences: Here the cast shadow is darker than the form shadows; the edges of the cast shadow are harder than those of the form shadows; the cast shadow shares the same hue as the surface it falls upon, not the object that casts it; and the cast shadow suggests the shape of the pear while "grounding" it in space.

LORI LOHSTOETER

Choosing a Light Source

Both form shadows and cast shadows are affected by the light source's angle, distance, and intensity. Intense light results in darker cast shadows; and the lower the light source, the longer the cast shadows will become. Keep in mind that the darkest shadows will always be on the side of the object opposite the light source. When painting indoors or setting up a still life, try using a portable lamp with an adjustable neck to experiment with different lighting angles and effects.

◀ **Using Strong Lighting** In this still life, the strong, low lighting from the side intensifies form shadows, creating dynamic contrasts and interesting shapes.

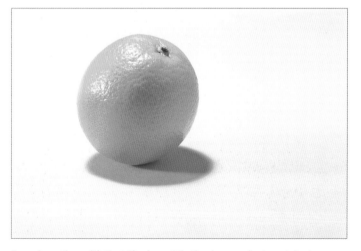

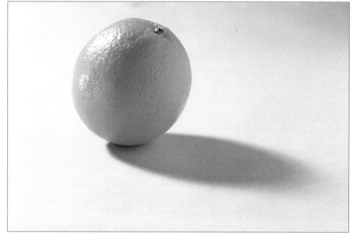

Experimenting with Cast Shadows Whether long or short, cast shadows can be an interesting element in a composition. In this photo, the light source is high and slightly behind the orange, creating a shorter cast shadow toward the front of the orange.

Lowering the Light Source Here the light source is low and coming from the left, so the cast shadow is long and falls to the right of the orange.

Creating Visual Interest with Light

Besides creating the illusion of form and dimension, the interplay between light and shadow also can be used to pique a viewer's interest in a scene. Because contrasting values attract the eye, incorporating subtle, natural contrasts between light and dark can add vitality and drama to a painting. For example, sunlight filtering through the leaves of a tree forms a variety of fascinating shapes that engage the viewer's interest. And sometimes patterns of light and shadow can be so compelling that they become the focus of the painting in lieu of the physical elements of the scene!

TOM SWIMM

Engaging the Viewer The irregular patches of sun and a range of warm values make this scene compelling and inviting.

▶ **Catching the Eye** A range of warm values and the play of light and shadow make this scene compelling and inviting. The shadows cast on the ground by the leaves and archways create a pattern that draws the eye into the painting and leads it down the pathway to the shadowed human figure.

BARBARA FUDURICH

Focusing on Shadows This snapshot captures the natural, delicate balance between light and shadow. For the painting, simplify the shadows but try to retain the delicate lace-like that makes them so interesting.

Depicting Time of Day

Light and shadow play a vital role in suggesting the time of day in a painting. The color temperature of light changes during the day, going from cool, light yellow in the morning to harsh white during the middle of the day. As the day passes, the light changes to a golden hue and turns to red before resolving into the cool evening colors of purple and blue. Your palette should respond to these changes in light. The shadows in your scene offer another way to communicate the time of day; for example, long, cool shadows are characteristic of morning, whereas short, colorless shadows evoke a midday feel.

Sunrise At sunrise, everything has a fresh, warm cast. As the cool night gives way to morning, colors are primarily yellow. Shadows are long and cool blue in color. This example shows a complementary color scheme, pitting the yellow-orange of the morning sun against the blue-purple of night shadows.

Midday At midday, the sun is directly overhead (at least in the summer), and all the colors are warm but washed out. There is little depth and interest in the colors. Shadows are basically nonexistent. Emphasize the brightness by allowing plenty of bright white paper to show through.

Sunset As sunset approaches, colors take on a golden cast, and shadows once again lengthen. As gold turns to orange and red, the shadows become warmer and redder. Colors once again become deep and rich. Sunset is similar to sunrise, but the colors have a warmer (redder) cast.

Dusk At dusk, everything becomes cool and dark. The sky still has a little light at the horizon, but it is primarily purple, deepening to blue. All objects appear as silhouettes rendered in dark blues, purples, and dark reds. Because there is no real light source, there is no shadow.

Night At night, all the light comes either from city light reflected in the sky, from street lights, or from building windows. The sky is a dark blue-black. Light comes from windows as bright white (the paper), changing to yellow, then red, then purple, and finally to blue to meld with the deep tones of nightfall.

Dawn On a clear morning, the sun rises in yellows and oranges. The air has cooled overnight, and moisture has settled the day's dust. Through this cleaner air, we see less red and more yellow.

Midday At noon, dust has been stirred up, making the atmosphere more dense than in the morning. At this time of day, colors look faded, and shadows are darker and more intense.

Dusk After a bustling day of city life, dust has built up in the atmosphere, so it has become very dense. For that reason, sunsets are often redder or pinker than sunrises.

Shadows and Reflections

Shadows

Believe it or not, color is often used in rendering shadows. Cool mixes of cobalt blue and opera or ultramarine blue and alizarin crimson are perfect for rendering shadows. Shadows across green grass are best represented by a mixture of phthalo blue and burnt sienna. In addition, shadows add clarity and depth to a scene. They also suggest a time of day and can be used to create drama and mood.

Shadows on White When painting white walls, use the same color underpainting for both the walls in shadow and in the sky, integrating the elements for harmony. This painting features ultramarine blue and alizarin crimson for the wall shadows above and at left, using strong, diagonal lines for extra excitement. The darkest shadow appears next to the brightest wall.

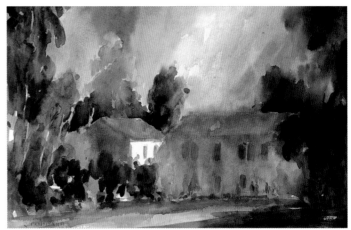

Foreground Shadows Exaggerating the length of the shadow along the ground, especially across the foreground, suggests late afternoon where all colors are saturated and the day is winding to a close. It also frames the subject and directs your eye upward. Remember to be consistent with the direction of light so all shadows come from the same place!

Reflections

Reflections are another great way to add energy and interest to a scene—and the best way to do this is through bright color accents, such as juxtaposing complementary colors: a red person against a green tree or a golden-yellow person against a purple shadow. To suggest the flow of water or irregularity of puddles, make horizontal strokes through the reflection. In city night scenes and lakes, the reflection extends down farther than the height of the object. Remember: If the reflection is distinct, the water is calm. Rivers and busy water have broken bits of color.

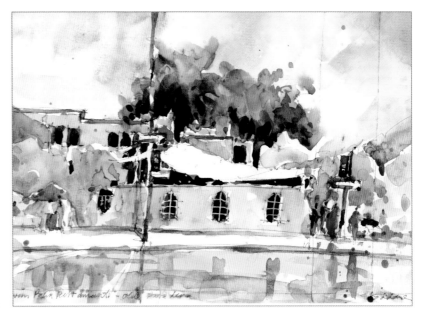

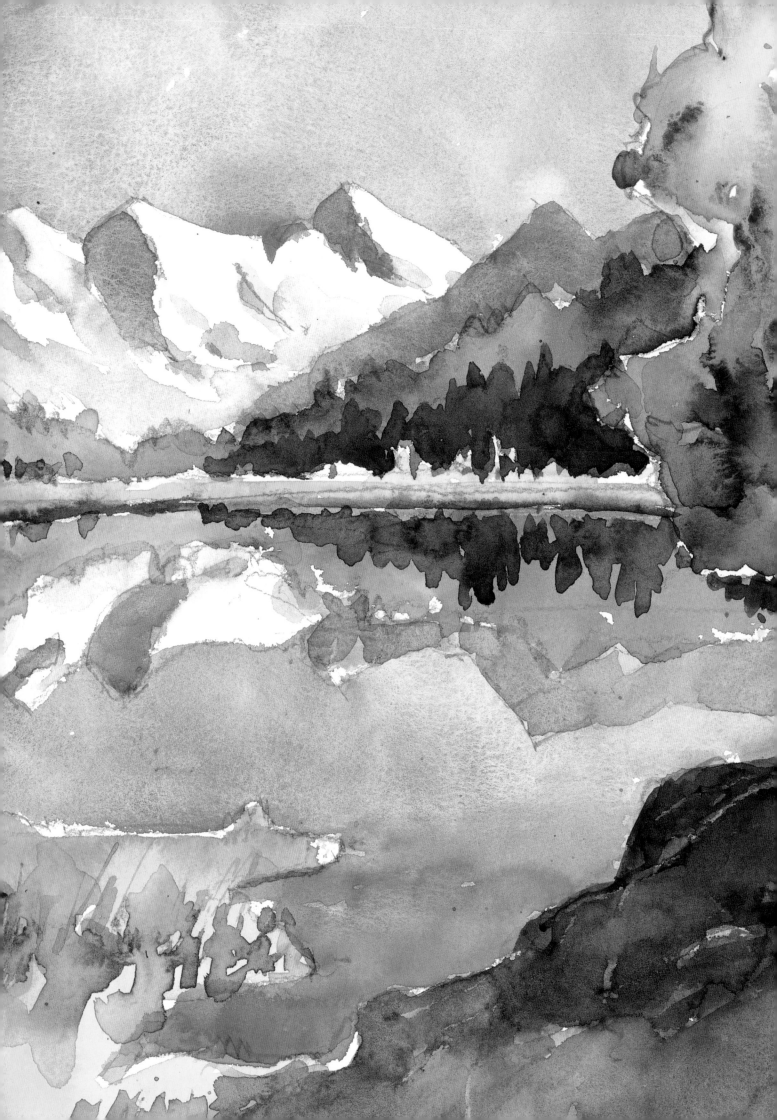

100 things every artist should know

CHAPTER 8

perspective and proportion

Linear Perspective

Perspective is the representation of three-dimensional space on a two-dimensional surface. It's responsible for creating the illusion of depth and distance. Many artists try to make perspective into something more difficult than it is. The truth is, you've already seen perspective in action—you just didn't know what to call it. The rules of perspective simply explain the reasons behind what you're seeing.

Understanding Linear Perspective

Linear perspective is the most commonly recognized form of perspective. According to its rules, objects appear smaller as they recede into the distance. When learning about linear perspective, the horizon line—a horizontal line that bisects any given scene—is an important concept. It can be the actual horizon, or it can be a line that falls at eye level—meaning at the height of your eyes, not where your eyes are looking. The vanishing point (VP)—or the spot at which all parallel lines in a scene seem to converge—is always located on the horizon line.

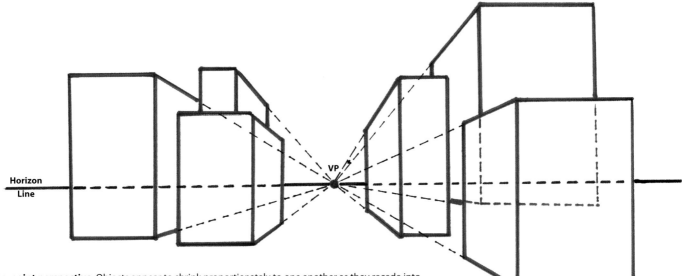

One-point perspective Objects appear to shrink proportionately to one another as they recede into space. When applying one-point linear perspective, all the horizontal lines converge at one vanishing point in the distance. The vertical lines all remain at the same 90 degree angle.

One-Point Perspective

When lines are all on one plane—such as with railroad tracks—the receding lines converge at one vanishing point. Think again of the railroad tracks—parallel stripes receding into the distance, with the space between them growing smaller until the lines merge on the horizon. Establishing the vanishing point will help you determine the correct angle for any lines coming toward (or moving away from) the viewer; but the angle of vertical or horizontal lines won't be affected. (See diagram above.)

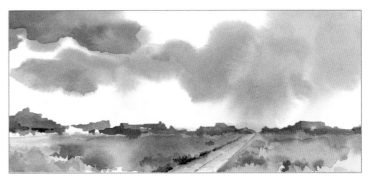

A road is one of the simplest ways to demonstrate one-point perspective at work—the lines converge at a distant point.

Don't get bogged down by perspective and spend hours working on angles, when all you want to do is paint. Just hold the pencil at arm's length, line it up with the angle you see, bring the pencil to paper and record it.

Two-Point Perspective

Two-Point Perspective

If a scene has more than one plane—for instance, if you are looking at the corner of an object rather than the flat face of it—then you should follow the rules of two-point perspective. With two-point perspective, there are two vanishing points. To find the vanishing points, first find your horizon line. Next draw a line that follow one of the object's angled horizontal lines, extending the line until it meets the horizon line. This establishes one vanishing point. Now repeat this process for the opposite side of the object to establish the remaining vanishing point. (Note: Sometimes a line will extend to a vanishing point that isn't contained on the page!) Each vanishing point applies to the angle of all parallel planes that are receding in the same direction. As with one-point perspective, vertical lines will all remain at the same 90 degree angle—only their size (in terms of length) will be affected by perspective.

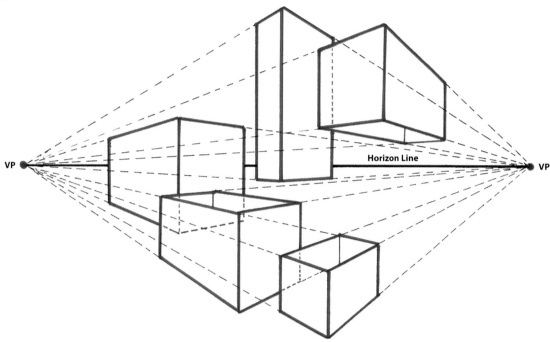

VP · · · · · · Horizon Line · · · · · · VP

◄ Applying the principles of perspective to your subjects will help you achieve realistic-looking sketches, but you don't have to follow the rules rigidly. When drawings are too tight or stiff, they lose their human quality; if you bind yourself to exact lines and angles, you might turn your lively street scene into an architectural drawing. Apply your artistic interpretation to a scene to create a more natural look.

▲ This painting is an example of two-point perspective.

Atmospheric Perspective Basics

Atmospheric perspective is critical to creating the illusion of depth and dimension in your work. Atmospheric (sometimes called "aerial") perspective is responsible for the way objects in our field of vision appear to change in size, color, texture, focus, and even brightness as they recede into the distance.

In nature, impurities in the air—such as moisture and dust—block out some of the wavelengths of light, making objects in the distance appear less distinct and with softer edges than objects in the foreground. And because the longer, red wavelengths of light are filtered out, distant objects also appear cooler and bluer. When applying atmospheric perspective, remember to paint distant objects with less detail using cooler, more muted colors, and remember to paint foreground objects with more detail using warmer, brighter colors.

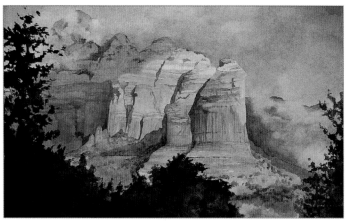

BARBARA FUDURICH

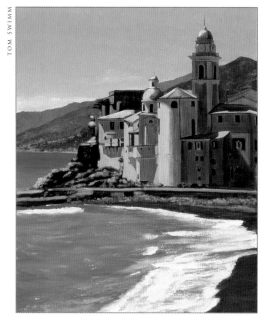

TOM SWIMM

In this coastal painting, the artist gives the elements in the foreground (the sunlit building and the rocks along the shore) the brightest, warmest colors, keeping them sharp in focus with more detail. He uses increasingly less detail for the hills and rocks along the distant shore, also applying more subtle, cooler colors as he moves into the background.

Using Atmospheric Perspective In this painting, the artist gives the elements in the foreground the brightest, warmest colors, keeping them sharp in focus and highly detailed. She uses increasingly less detail for objects in the distance, also applying subtle, cooler colors as she moves into the middleground. The objects in the background are the most muted with blurred, unfocused edges.

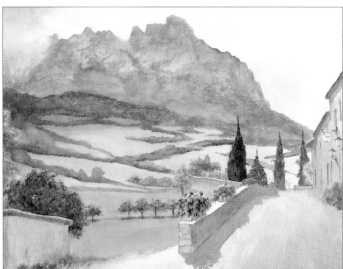

BARBARA FUDURICH

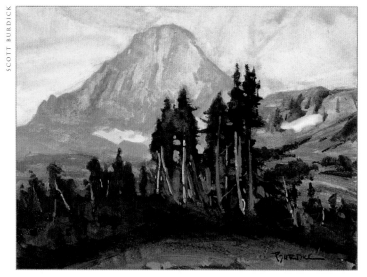

SCOTT BURDICK

Using Muted Colors Here the artist rendered the background elements (the mountains and the foliage in front of them) with cooler, bluer colors, which pushes them back into the picture plane and creates the illusion of distance. Note that the green foliage in the foreground is much brighter and more detailed; also, the red flowers in the foreground are quite distinct, but become blurred and muted as they recede into the distance.

Recognizing Atmospheric Perspective Although the foreground of this painting is in shadow (and therefore the objects closest to the viewer are muted), the artist still employs atmospheric perspective to create the illusion of distance between the middleground and the background. When placed against the cool, vague mountain in the distance, the warm, reddish hills and well-defined crevices of the middleground seem to "pop" forward.

More About Atmospheric Perspective

Here are some more techniques using atmospheric perspective.

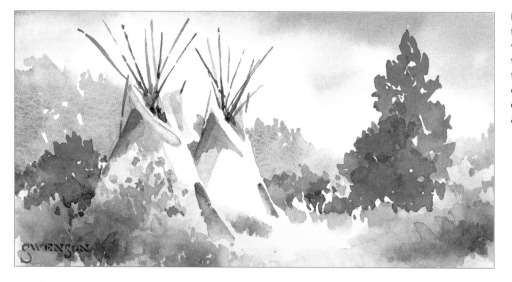

Distinguishing the Planes The foreground shrubs boast the most vibrant foliage color and detail in this scene. In the middle ground, the trees have a softer, more out-of-focus look. And the trees in the distant background are grayed and indistinct.

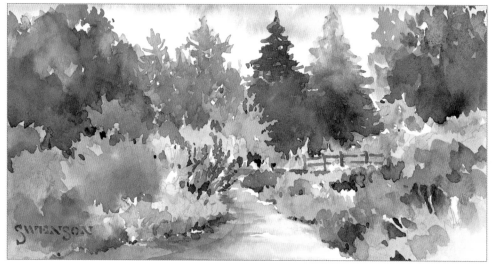

Pairing Perspectives Linear perspective is responsible for the way the path narrows as it leads into the distance. But atmospheric perspective accounts for the blurring of forms and dulling of colors in the distance.

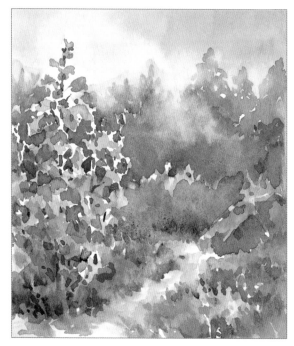

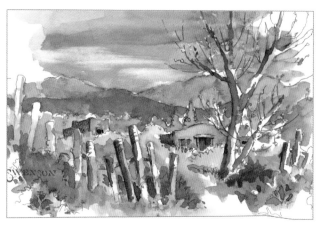

▲ **Sizing and Overlapping Elements** The house pictured here would be taller than the fence if the two elements were placed side by side—but enlarging the posts makes them appear nearer. Similarly, overlapping the house with the tree pushes the house into the distance, creating a more realistic sense of depth.

◄ **Implementing Color Distinctions** The contrast between the bright warm flower shapes in the foreground and the hazy, gray trees of the background help explain why Leonardo da Vinci called atmospheric perspective "the perspective of disappearance!"

People in Perspective

Knowing the principles of perspective (the representation of objects on a two-dimensional surface that creates the illusion of three-dimensional depth and distance) allows you to draw more than one person in a scene realistically. Eye level changes as your elevation of view changes. In perspective, eye level is indicated by the horizon line. Imaginary lines receding into space meet on the horizon line at what are known as "vanishing points." Any figures drawn along these lines will be in proper perspective. Study the diagrams below to help you.

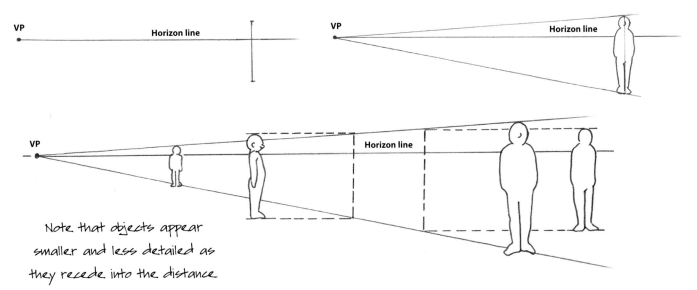

Note that objects appear smaller and less detailed as they recede into the distance.

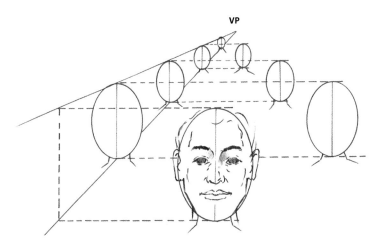

Try drawing a frontal view of many heads as if they were in a theater. Start by establishing your vanishing point at eye level. Draw one large head representing the person closest to you, and use it as a reference for determining the sizes of the other figures in the drawing. The technique illustrated above can be applied when drawing entire figures, shown in the diagram below. Although all of these examples include just one vanishing point, a composition can even have two or three vanishing points.

If you're a beginner, you may want to begin with basic one-point perspective. As you progress, attempt to incorporate two- or three-point perspective.

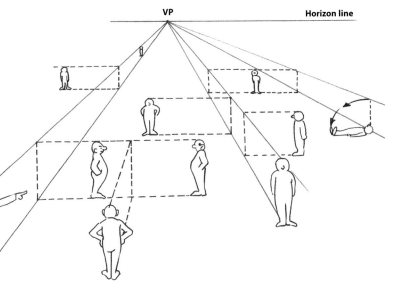

Foreshortening

Foreshortening causes the closest part of an object to appear larger than parts that are farther away. Technically foreshortening pertains only to objects that are not parallel to the picture plane. Because of your viewing angle, you must shorten the lines on the sides of the nearest object to show that it recedes into the distance. For example, if you look at someone holding his arm straight down against the side of his body, the arm is perfectly vertical (and parallel to the picture plane), so it appears to be in proportion with the rest of his body. But if he raises his arm and points it directly at you, the arm is now angled (and no longer parallel to the picture plane), so it appears disproportionate to the rest of his body. (The hand looks bigger and the arm looks shorter.) So you would draw a large hand and an arm with shortened sides.

Recognizing Foreshortening This drawing is an excellent example of foreshortening. Notice the difference in size between the boy's foot (closest to the viewer) and his head (farthest from the viewer).

Simplifying Foreshortening
You can use this simple exercise to better understand the logic of foreshortening. All you'll need is your own hand and a mirror!

Fingers Straight Up
Hold your hand in front of a mirror, palm forward. Notice that your fingers are the correct length in relation to your palm. Nothing is foreshortened here.

Fingers Angled Toward You Now tip your hand forward a little, and see how the lengths of the fingers and the palm appear shortened. This is subtle foreshortening.

Fingers Angled Down When you turn your fingers so they're angled down, they appear longer but still not full length, though the fingertips are visible. This pose shows some foreshortening; the fingers seem too long and thick in relation to the back of the hand.

Fingers Pointing Forward Now point your fingers straight at you. This is the most extreme foreshortened view; the fingers appear to be mere stubs.

Fingers Pointing Straight Down No foreshortening is at work in this frontal view. The tips of the fingers cannot be seen, and the lengths of the fingers and hand are not at all distorted.

Proportions of the Body: Measuring Your Subject

Maintaining proper proportions when drawing will help you achieve a lifelike quality. Artists throughout history have used eight heads as the proportional height of a figure. Once you establish a unit of measurement such as the head of your model, it is best to return to the original unit of measurement to check your height and width. This will ensure the correct proportion for the figure being drawn.

Male figure, 8 heads high
General points of intersection:

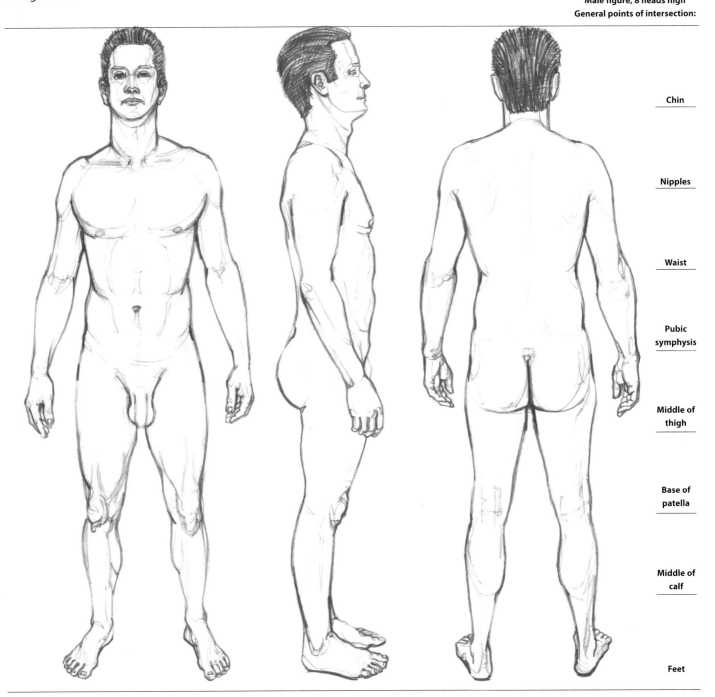

Chin

Nipples

Waist

Pubic symphysis

Middle of thigh

Base of patella

Middle of calf

Feet

Measuring your Subject 1. From your point of view, hold the divider in your hand, stretch out your arm, and lock your elbow. It is imperative that you keep the divider the same distance between you and what is being measured. Do this every time you check a measurement in a drawing. 2. Spread open the divider and adjust it so that one point is on the top of the head and the other point is on the bottom of the chin. You might want to close one eye. This will give you the size of the figure's head from your point of view. Use this size as your unit of measurement. You can see by the diagrams above that the male and female figures are eight heads high. 3. You can also measure the figure you're drawing by its width in heads. Male shoulders are generally 2 heads wide, but female shoulders are a bit smaller, measuring 1-3/4 heads wide. Once you've established these measurements, switch to a new unit of measurement, such as half of the entire figure. The more you measure and compare, the more accurate your drawings will be!

Proportions of the Body: Points of Intersection

Remember that everyone is different. Each individual has his or her own unique proportional relationships or ratio of parts to the whole. Being true to the figure will help create individuality and realism in your drawing. Artists who rely on formulas create stylized figures that frequently lack true representation of the subject.

Female figure, 8 heads high
General points of intersection:

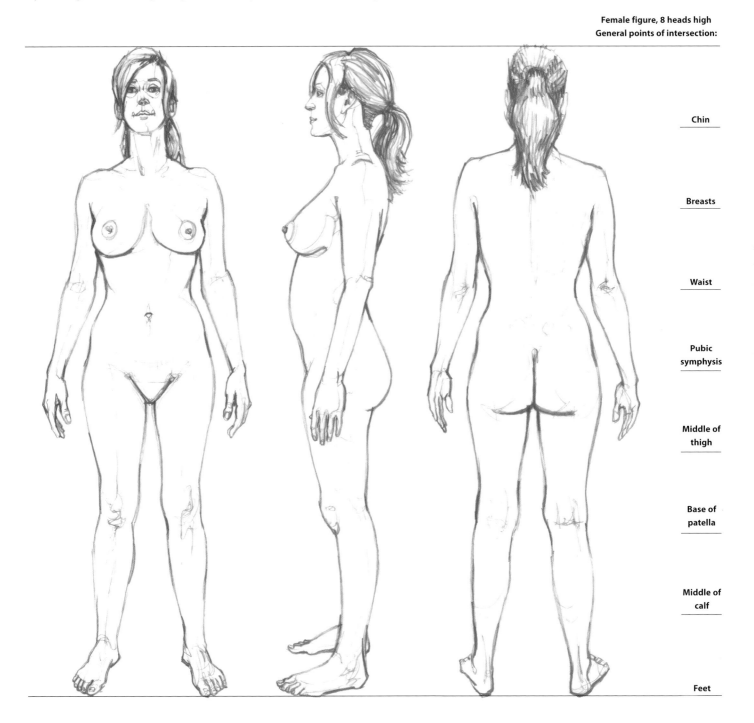

Chin

Breasts

Waist

Pubic symphysis

Middle of thigh

Base of patella

Middle of calf

Feet

General Points of Intersection As shown to the right of the figures above, the general points of intersection are the chin, breasts, waist, pubic symphysis, middle of thigh, base of patella, middle of calf, and feet. You can use these as reference points, adjusting them to each unique individual. Note that if you're viewing a figure from the side, the halfway mark (or pubic symphysis line) intersects the great trochanter; if you're viewing a figure from the back, the halfway mark intersects the coccyx.

Point of View Always maintain and return to the same point of view when drawing. To help, you can mark your location on the ground with tape. Remember to return your head to the same position or point of view when assessing your work. Even the slightest movement from your original position is problematic. The smallest tilt or change in your head position will change the look of your subject, affecting the relationships of the parts of the figure to the whole. Using your divider will work only if you maintain the same point of view.

Proportions of the Head

Using a standard set of measurements helps the artist create accurate proportions when constructing a head drawing. In this section, you'll find measurements that can serve as general guidelines for your head drawings. These proportions are created from averages of the human population at large; however, remember that all people are not the same—they are individuals with varying proportions, and it is these variations that make us different from one another. Solely relying on standard measurements will result in a stylized portrait.

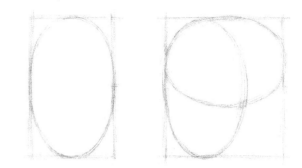

Step One Begin with simple shapes first. A) Frontal: Start with a vertical rectangle. Inside, draw a single oval that includes the cranial and facial mass. B) Profile: Begin with a square. Then use two separate ovals connected at the forehead to draw the facial and cranial mass. In both drawings, the halfway point is lightly marked along the vertical line.

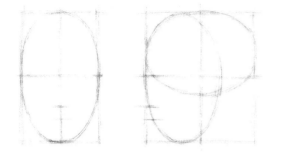

Step Two A) Frontal: Draw the major axis (vertical) to indicate the centerline of the face. Then add the minor axis (horizontal) to place the eyes. The tops of the eyelids are approximately halfway down the face. Draw a line halfway from the eye line to the chin to mark the base of the nose. The mouth is usually one-third of the way from the base of the nose to the chin. B) Profile: Divide the square into four by drawing a cross in its center. Mark nose and mouth measurements as in the frontal view (A).

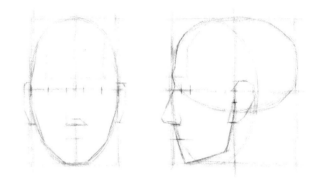

Step Three A) Frontal: A head is roughly five eyes wide. Divide the eye line into five equal units, with one unit of measurement in the center, between the actual location of the eyes. The tops of the ears are slightly higher than the eye line. The bases of the ears correspond to the base of the nose. Draw the ears with simple shapes first using straight-line segments. Starting with the line for the brow ridge above the eye line, block in the forehead and base of the nose. B) Profile: Indicate the center of the ear in profile with a dark cross slightly below the center of the square. The space from the front of the face to the ear is approximately seven profile eye widths. Other ear measurements correlate with the frontal view. Place the eye approximately two eyes in from the front arch of the face. Now draw the angles of the nose and jawbone. Separate the forehead from the side of the head.

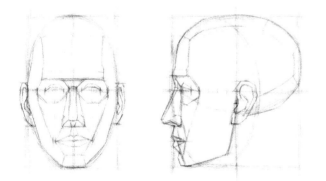

Step Four Everything on the face has a front, top, and bottom. When drawing the eyes, start with the eye socket first, using straight lines to create the overall shape. Then move to the upper lid. Articulate the nose with a bridge, sides, and base; then draw the planes of the face. Add the philtrum, which connects the base of the nose to the upper lip. Chisel out the cranial mass further. Develop the ear shapes, making them more organic and specific. Increase the line weight and override the measurement lines.

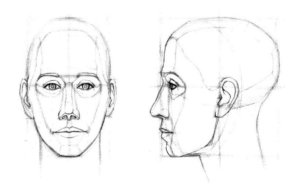

Step Five Now fluctuate the contour line to reveal the organic qualities of the face. Add the iris and pupil. The upper and lower lids of the eye eclipse portions of the iris. Articulate the eyebrows with simple shapes, and place the nostrils at the base of the nose. Reveal the protuberance of the mouth using lines from the nostrils to the corners of the mouth. Then add the contours of the neck and the hairline to separate the face from the rest of the head.

Foreshortening Head Measurements

Foreshortening occurs when parts of an object nearest the viewer appear larger than parts that are farther away. For example, have someone stand in front of you with arms at his or her side. Take note of the size relationship of the hand and the head. Now have the person hold out a hand toward you, palm facing you. Notice that the hand now appears much larger in proportion to the head. This illusion is foreshortening in action.

Applying the rules of perspective and foreshortening helps create the illusion of volume and space. Mastering these principles results in more dynamic poses and compositions. Poses and perspectives that involve foreshortening can be more challenging than others. The obstacle is to overcome drawing *what you think you know* and instead draw *what you observe and truly see*. In a three-quarter view of the head, such as the drawings below, the model is looking off to one side. Plenty of beginners make the far side of the face too large and fail to eclipse the tear duct with the bridge of the nose. This is because people are accustomed to seeing a face in frontal view. These beginners are drawing what they think they know—not what is in front of them.

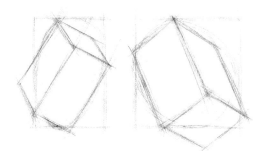

Step One Starting with a simple box for the head allows you to see the major planes, indicate whether the model is looking up or down, and establish which side of the head we see. First, lightly draw a rectangle or square—whichever shape best fits your model's head. If the model is looking down and to the right, you should see the top, left side, and front of the box. If the model is looking up and to the left, you should see the bottom, right side, and front of the box.

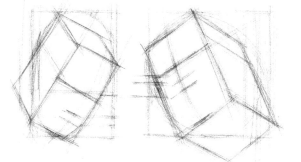

Step Two Mark the positions of the eyes, nose, mouth, and ears. Notice how foreshortening changes the marks from the frontal and profile views. When the model is looking down, it is important to know where the forehead becomes the top of the head. Then your measurements are easier to place on the front of the face. When the model is looking up, foreshortening appears more extreme. The eyes are high on the front of the face, reducing the amount of forehead seen. Foreshortening changes the ear line in relation to the other measurements and reduces the distances between the eyes, nose, and mouth. Check your angles and measurements—the relationships among features can be deceiving.

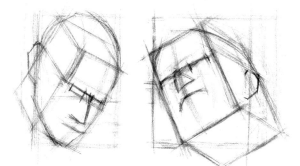

Step Three Begin chiseling out the shape of the head from the box using straight-line segments. When the model is looking down, we do not see the base of the nose. But when the model is looking up, we see plenty of the base. The arc of the mouth wraps with the curvature of the face and depends on the position of the head. Begin drawing the ears using straight lines that show where the curves change direction. Block in the eyes using rectangles.

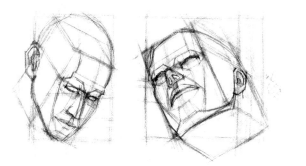

Step Four Further develop the planes of the head. Build the eye sockets before refining the eyes; this allows you to analyze the shapes around the eye for proper construction. Determine the shapes contained in the ears. When the model is looking down, focus on the bridge of the nose; when the model is looking up, focus on the nostrils. At this point, some straight-line segments should slowly become more organic.

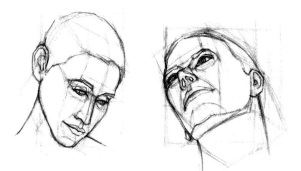

Step Five In this step, increase your line weight to suggest value and create focal points or areas of interest, such as the eyes. Use more defined contour lines to articulate the organic qualities of the human head and define the major forms. Separate the hair shapes from the "mask" of the face, and add the eyebrows. Draw the contours of the neck as they relate to the gesture of the head.

100 things every artist should know

CHAPTER 9

composition

Introduction to Composition

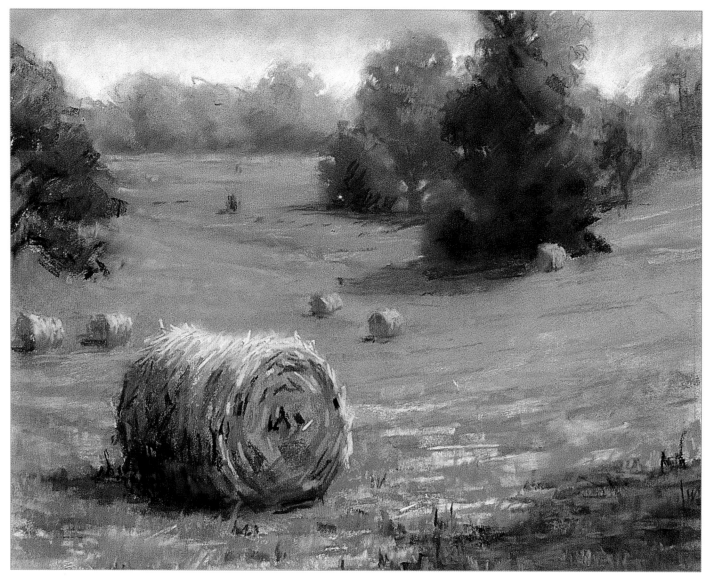

The key to creating dynamic paintings is designing a pleasing composition—the arrangement of objects in a painting and the way in which they relate to one another. A good composition will appear balanced and harmonious, with the various elements working together to create an eye-catching scene. Over the next few pages, you'll discover how to establish a center of interest, or focal point; create a visual path that leads the viewer's eye through the painting; organize the elements in your painting; and choose a format—horizontal, vertical, or panorama—that complements your subject.

Positive and Negative Space

The interplay of positive and negative space in a work of art is an important dynamic often brushed aside by beginners. Paying close attention to how they work together to influence the shape, balance, and energy of the work can help you improve and refine your compositions.

Positive space is the area in your work occupied by the subject, whereas negative space refers to the area between and around the subject. Think of negative space as a support system for your positive space; it should not take attention away from the positive space but instead should complement it. For example, negative space can echo the shapes of the subject to create rhythm within the work.

Sometimes a beginner's tendency is to fill a picture plane with as much subject matter as possible, cramming the scene with forms and utilizing every inch of empty space. However, the eye relies on areas of inactivity to rest and digest the scene as a whole. Many artists suggest aiming for a balance of positive and negative space, as too much of one can create a sense of excessive "fullness" or "emptiness." Others argue that using equal parts of positive and negative space creates confusion; the eye doesn't know where to focus. So, what to do? My advice is to let either the positive or negative space subtly dominate the composition. Play with ratios until you feel the dynamic best communicates your message.

▲ **Painting Negative Space** Negative space is the empty space between objects. If an object appears too complex, focus on the negative space instead. You can do this by squinting your eyes, which blurs the details so you can only see the negative and positive spaces. When you draw the negative shapes around an object, you're also creating the edges of the object itself.

Creating a Focal Point

A key element in creating a successful composition is including more than one area of interest, without generating confusion about the subject of the drawing. Compositions are often based on one large object, which is balanced by the grouping, placement, and values of smaller objects. Directing the viewer's eye with secondary focal points helps move the viewer through a scene, so that it can be enjoyed in its entirety.

The primary focal point should immediately capture the viewer's attention through size, line quality, value, placement on the picture plane, and the proximity of other points of interest which call attention to it. The secondary focal point is the area that the eye naturally moves to after seeing the primary focal point; usually this element is a smaller object or objects with less detail. Another secondary focal point may be at some distance from the viewer's eye, appearing much smaller, and showing only minor detailing, so that it occupies a much less important space in the drawing. This distant focal point serves to give the viewer's eye another stop on the journey around the composition before returning to the primary focal point.

Primary, Secondary, and Distant Focal Points The size and detail on the pelican designates it as the primary focal point, and it immediately catches the viewer's eye. The pelican's gaze and the point of its bill shifts the attention to the small birds in the foreground (the secondary focal point). By keeping the texture and value changes subtle in the middle ground, the eye moves freely to this point. These three small birds are shaded fairly evenly so they don't detract from the primary focal point. The triangle created by the birds, along with the water's edge and the point of land, leads the viewer's eye to another, more distant focal point—the lighthouse. Here the two subtle rays of light against the shaded background suggest a visual path. The rays of light, the point of land, and the horizon line all work together to bring the viewer's eye back to the pelican, and the visual journey begins again.

Leading the Viewer's Eye

Once you've determined the focal point of your painting, you need to decide its position. You don't want your viewers to ignore the rest of the painting, so your focal point should be placed in such a way that the viewer's eye is led into and around the entire painting, rather than focusing only on the center of interest. You can lead the eye using a number of techniques: incorporating diagonal and curving lines, avoiding symmetry, overlapping elements, and composing with light and color.

TOM SWIMM

Composing with Curving Lines In this landscape, the curving road creates an inviting path that guides the viewer's eye from the cool, bluish shadows to the warm, glowing fields and sunlit buildings.

Using Diagonal and Curving Lines

Even if the focal point of your painting is fairly obvious, you should emphasize the center of interest by using visual "signposts" to direct the viewer's eye toward it. Diagonal and curving lines often lead the eye from one of the corners of a painting to the center of interest. (For example, a diagonal street or a curving stream.) Curving and diagonal lines also can be formed by the placement of elements within the painting.

Avoiding Symmetry

One of the most basic rules of composition is to avoid too much symmetry in your paintings. Placing your focal point in the middle of the scene, for example, divides the painting in half and results in a static, dull composition. Placing the center of interest slightly off center, however, creates a much more dynamic, pleasing composition. This leads the eye around the entire painting, rather than inviting it to focus solely on the center of the composition. Try working out asymmetrical designs on scrap paper with thumbnail sketches—small compositional studies—before committing to a design.

Poor Design In this thumbnail sketch, the elements are crowded into the center and are all on the same plane. The shapes are too symmetrical and uniform, and the eye is led out of the picture.

Good Design Here the center of interest is placed farther to the left; the elements are staggered on different planes and are overlapped; and the curving path directs the eye into the scene.

The Rule of Thirds

Determining the Focus

Determining the subject of your painting is only the first step; the next is to design the composition. To do so, ask yourself, "What do I wish to say?" The answer to this question will establish the center of interest—or focal point—of the painting. Surprisingly many artists don't know what or where their center of interest is; and if they don't know, neither will the viewer!

Once you've determined the focal point, you need to decide on its placement. You can always create a well-balanced composition if you follow the rule of thirds, also called the "intersection of thirds"; to follow this principle, divide the paper into thirds horizontally and vertically. Then place your center of interest at or near one of the points where the lines intersect. It's as simple as that! The rule of thirds keeps your center of interest away from the extremes—corners, dead center, or the very top or bottom of the composition—all recipes for design disaster. The result is a piece that holds the viewer's interest!

Approaching the Painting The rule of thirds helped locate the focal point of this painting. Note that the area containing my focal point has the greatest amount of detail and contrast; it features the lightest lights and the darkest darks.

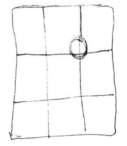

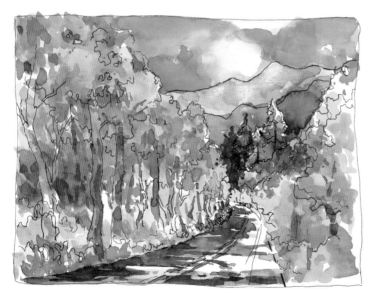

Testing Your Designs

Even when applying the rule of thirds, you'll usually find that you have a selection of designs to choose from. Thumbnail sketches—or small compositional studies—are the insurance policy of smart artists! They allow us to quickly work out a composition before committing time and effort to a sketch or painting. These sketches are small—2 to 3 inches at most—but they contain the necessary information about a scene's arrangements and values. It's always wise to make a few thumbnails before committing to a design.

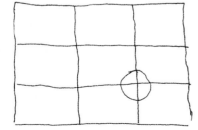

The Golden Mean

The composition of most classical art is based on the Golden Mean, also known as the Golden Ratio, Golden Section, or the Divine Proportion. In ancient Egypt and Greece, design used a constant factor in a geometric progression, and that ratio was first calculated by a mathematician known as Fibonacci in the 13th century. The Golden Mean, or 1.618, is the constant factor in his continued proportion series: 1, 1, 2, 3, 5, 8, 13, 21, 34, 55, 89, 144, and so on. By adding the last number to the previous number, we arrive at the next number in the series; for example, 21 + 34 = 55, 55 + 34 = 89, and so on. By dividing any number by the previous, we get a result close to 1.618. In a continued proportion, the closest pair of numbers to the Golden Mean of 1.618 is 55 and 89—these two numbers are used most frequently in fine design to establish proportionate space.

Finding the Golden Mean in Nature

Examples of the Golden Mean are all around us in nature: the structure of sea shells, leaf and petal groupings, pinecones, pineapples, and sunflowers, for instance.

Naturally Occurring Ratio The Golden Mean ratio and spiral pattern also can be seen in the structure of most pinecones. Note how the individual pieces spiral up from the bottom of the cone. There actually are two spiral patterns: one to the left and one to the right. Different types of conifers generate different spiral patterns. The pineapple spirals in this same manner.

The "Perfect" Ratio of 89:55 The center of the daisy, like the sunflower and other plants with large seed heads, shows the geometric pattern formed by the Golden Ratio. As the seeds or pistils move out from the center of the flower, they create spiral patterns that curve to the right and left at an 89:55 ratio.

Constant or Geometric Spiral The conch shell shown here demonstrates the Golden Mean—as each section of the spiral naturally increases in size by 1.618 as it moves outward. This is called the "constant spiral" or "geometrical spiral."

Finding the Golden Mean of a Line

The 1:1.618 ratio is used by designers and artists in all media, such as architects, engineers, cabinet makers, and many other creative people. In this exercise, we concentrate on dividing a line into what is commonly accepted as the most aesthetic division.

You can find the Golden Mean of any line by measuring it and using a calculator to divide that number by 1.618 (Method 1). Mark a point at that measurement on the line to divide it into two segments of the perfect proportions. You can continue to divide each smaller section of the line by 1.618 to create more divisions in the Golden Mean ratio. You also can use simple geometry to achieve the same results that the Greeks used in their design (Method 2). Just follow the steps below that illustrate each method.

Method 1: Calculator

Step 1 Begin by drawing a line of any length and label the two endpoints as A and B. This particular line is 4 cm long.

Step 2 Divide the length (4 cm) by 1.618. The number you get (in this case, 2.47 cm) is the distance between A and C above.

Method 2: Geometry

Step 1 Begin by drawing a line of any length and label the two endpoints as A and B. Divide the line length in half and mark the center point.

Step 2 Draw a perpendicular line at point B that is equal in length to half of line AB (the measurement from the center point to A or B). Label the end of the new line point C (BC = 1/2 AB).

Step 3 Draw a circle with the center at point C and BC as the radius.

Step 4 Draw a line from A to C. Label the point where line AC passes through the circle as point D.

Step 5 Using point A as the center and AD as the radius, draw a partial circle which intersects line AB; that intersection is at point E (EA = AD). You should find that line AE equals a division of 144/89 and line EB equals a division of 89/55, where 144 is the original line length (AB). Contrast is created by the differing sizes of lines AE and EB, and unity is created by the correlation of line EB to the entire line AB (the Golden Mean).

Forming and Placing Elements

The basic shapes used in creating visual art—the square, rectangle, circle, and triangle—are two-dimensional (2-D). The diagrams below show how to create the illusion of depth (three dimensions or 3-D) by extending each 2-D shape. These 3-D forms are combined and modified to form the elements we draw. For an effective composition, they must be overlapped on the picture plane to unify the elements and provide depth. At the same time, the arrangement must display balance in which the elements' size, placement, and value occupy the space to create a harmonious composition.

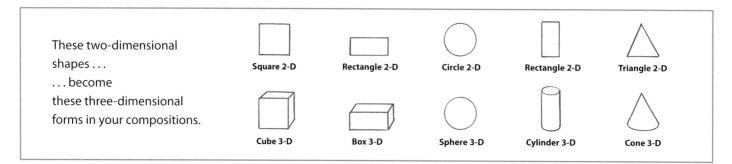

These two-dimensional shapes . . .
. . . become these three-dimensional forms in your compositions.

Square 2-D Rectangle 2-D Circle 2-D Rectangle 2-D Triangle 2-D

Cube 3-D Box 3-D Sphere 3-D Cylinder 3-D Cone 3-D

Arranging Elements in a Still Life

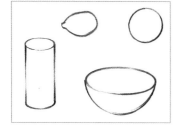

Turning Shape into Form Derived from basic shapes, these elements can be used in a still life composition. Cut a sphere in half for a bowl. A circle can become an orange; a cylinder, a can. Stretch a circle horizontally to create a lemonlike ellipse.

Monotonous Composition Placing the elements in a continuous line, as shown here, creates monotony and boredom. There is a slight sense of depth achieved by overlapping, but all the attention is focused on the last item, the vertical can.

No Depth or Balance This C-shaped composition offers a slightly better placement, but when elements are just touching—not overlapping—nothing creates depth or balance.

Pleasing Composition Here some elements overlap—the orange is placed in the bowl for further interest. The elements balance one another and hold the viewer's interest.

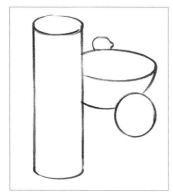

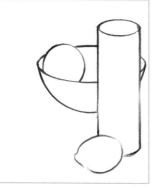

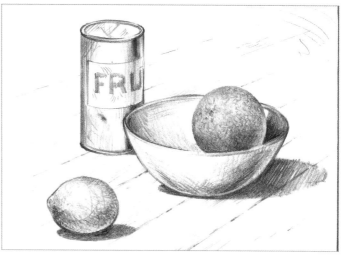

One Dominant Element This arrangement is fairly comfortable, even though the cylinder is quite dominant. If you wish to emphasize one major element, be sure that it is worthy of the attention and that the other elements support it. Overlapping the objects creates depth and supports the cylinder.

Unbalanced Placement Even though all these objects are overlapping and the orange is once again placed in the bowl for interest, the viewer is left with the feeling that everything is falling off the page. In addition, the side of the cylinder is at the center of the bowl, visually cutting the composition in half.

Placing Still Life Elements This finished sketch uses the "Pleasing Composition" thumbnail above as a guide. The two-dimensional shapes of the thumbnail have been transformed into three-dimensional forms through shading to create highlights, shadows, textures, and a surface (the wooden table). The finished composition shows depth and dimension.

Selecting a Viewpoint

After we have selected a subject for our composition, begin by considering viewpoint—the position from which we observe and portray our subject. The viewpoint incorporates the angle of view (from which direction—right, left, or centered—we observe the subject) and the elevation of view (how high or low our position is when viewing the subject). Once these basics have been determined and our composition is finalized, our viewpoint cannot change throughout the drawing process. We must view the subject and all other related elements from the same position at which we started. Objects and structures change greatly, as does the entire composition, if we move from one angle of view or elevation to another.

Angle of View

The viewpoint extends from our eye to the horizon and includes everything we see from a selected, set position. If we move right or left, changing our angle of view, dramatic changes take place in the way we perceive and record the objects and the overall scene. When you are setting up a composition for a drawing, survey your subject from all angles to find the view that will enhance it best. Consider the surrounding elements that you believe will most dynamically highlight the subject. Once these decisions are made, begin refining your composition.

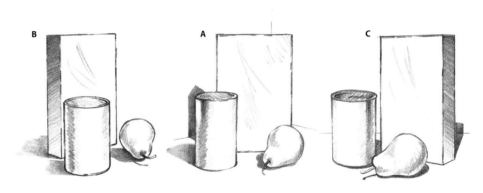

Changing Angle of View Above is an overhead view of an artist looking at a still life composition—a can , a box and a pear—from directly in front of it (A). The dotted lines represent the line of sight. As the artist moves to his left (B) and right (C) to achieve different angles of view, the appearance of the composition changes, as seen in the three illustrations at right.

How the Angle of View Affects the Composition From the A position in the diagram above, the artist sees the composition as it appears in the thumbnail sketch A, shown here. When the artist moves from that angle of view to points B or C, the composition changes as seen here in the left and right sketches; notice the differences in how all the objects appear and relate to one another in these three sketches. Also observe the change in the composition as a whole. Shifting your angle of view changes virtually everything in the composition; thumbnail sketches like these can help you see the differences in your own compositions.

Elevation of View

The elevation of view can be high, level (straight on), or low. From a high angle of view, we look down on the object and see the top and front; in this case, the object's placement on the picture plane is above the horizontal center. In a straight-on view, we see only the front of the object; its position is at eye level, near the middle of the picture plane. But from a low angle of view, we see the bottom and front of the object; its location on the picture plane is below the center.

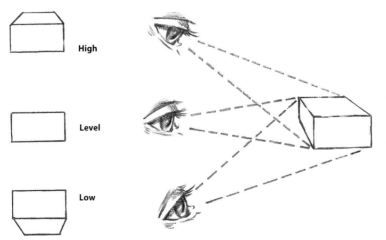

Changing Elevation of View High, level, and low elevation views of the same simple box result in three very different depictions of the subject (shown at the left side of the diagram).

Index